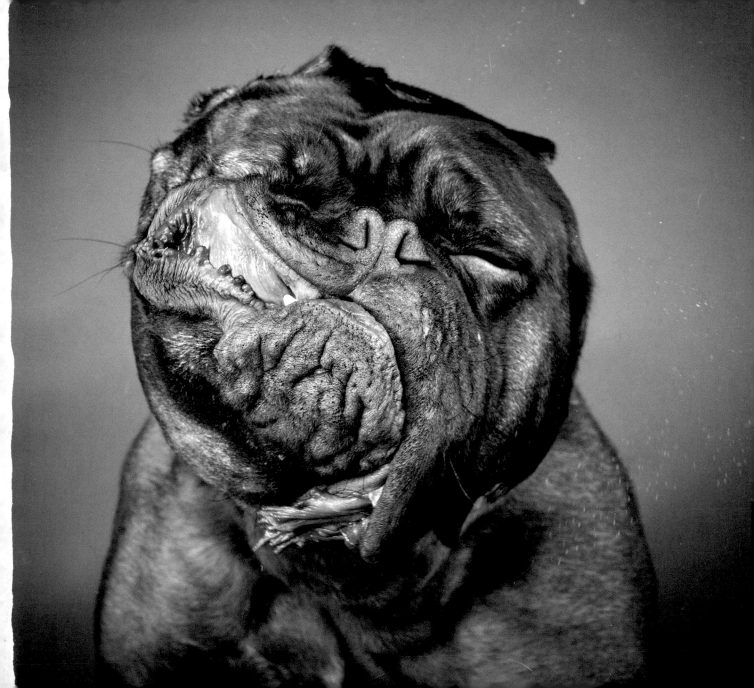

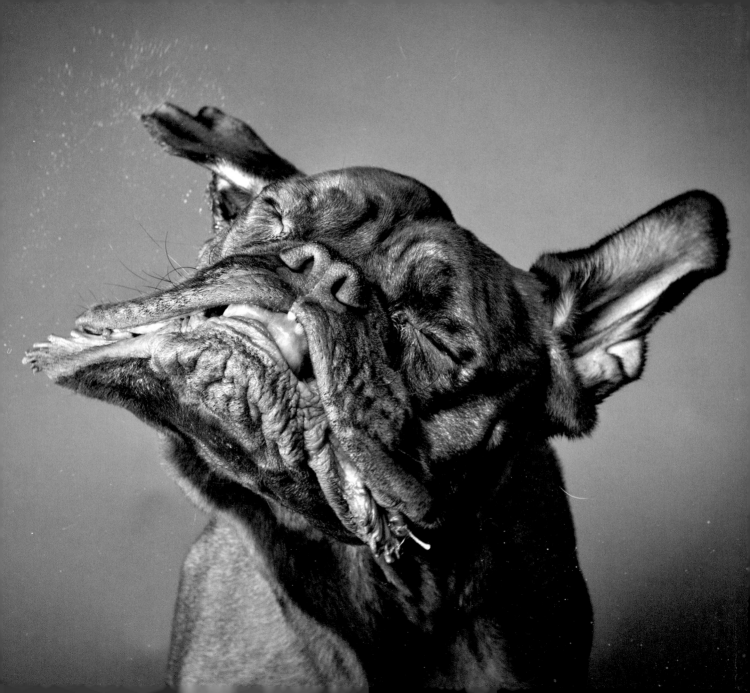

SHAKE

CARLI DAVIDSON

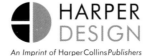

HARPER
DESIGN
An Imprint of HarperCollins Publishers

HarperCollins books may be purchased for educational,
business, or sales promotional use. For information please e-mail
the Special Markets Department at SPsales@harpercollins.com.

Published in 2013 by
Harper Design
An Imprint of HarperCollins*Publishers*
10 East 53rd Street
New York, NY 10022
Tel: (212) 207-7000
harperdesign@harpercollins.com
www.harpercollins.com

Distributed throughout the world by
HarperCollins*Publishers*
10 East 53rd Street
New York, NY 10022

Library of Congress Control Number: 2012953855

ISBN: 978-0-06-224264-8

Printed in China, 2013

This book is dedicated to my dogs, Norbert, Jack, Dempsey, Ashes, Daisy, and Chloe. Over the years you have saved me a fortune in psychiatrist bills, and for that I am grateful.

It is also dedicated to my father, Charles Davidson, who taught me how to catch snakes when I was six years old. "It might bite you," he said, "but remember, it's more afraid of you than you are of it, so be gentle. To it, you're a giant!"

Also to my husband, Tim, whose fascination with being married to an eccentric artist is ever enduring and much appreciated.

INTRODUCTION

Seven years before I was born, a bulldog saved my family's lives. Daisy was only a puppy at the time, but her shrill bark woke my father to a house filled with thick smoke after an oily rag burst into flame. He roused my mother, and together they grabbed my sisters and Daisy and made it outside to safety.

I was born just in time to meet Daisy—a snorting, drooling bundle of skin. Her grunts and generous licks are some of my earliest memories. I also grew up with our dogs Jack, Dempsey, Chloe, and Ashes, our cat, Hulk Hogan (named after my hero), and a multitude of reptiles and amphibians. I cared for them, played with them, and was comforted by them while I struggled with adolescence. I also watched them age, and mourned them when they passed. Each one of them is part of the reason why I have so much awe and respect for the animals around me. They keep me grounded by providing me with totally honest interactions and an environment in which I give and receive unconditional affection.

Growing up next to a nature preserve gave me the opportunity to work with animals from a young age. I watched butterflies emerge from cocoons and pump their withered wings to fullness. I watched spiders spin their webs, in awe of their attention to detail. I caught frogs for fun, hunting them like I had seen my cat hunt them and then pouncing on them with cupped hands. Through animals I learned the mysteries of life and death, and the miracles of the everyday. It's no wonder I've worked with them for most of my life. I've been a zookeeper and a conservation educator. I've also volunteered with wildlife and pet rescues, which taught me how to work with animals from different backgrounds.

After years of working in the fields of photography and animal care, I set my focus on running a photo studio. I no longer don coveralls and spend hours cleaning enclosures and prepping diets. Instead I spend more time with my dog, Norbert, on a daily basis than with anyone else. I listen to his droning snores and grunts as I work, and I observe him eternally trying to find the softest spot on his bed. He stretches each time he gets up, and then he shakes his whole body, peppering the walls with saliva

from his plentiful jowls. He's given me thousands of these shakes throughout the years, and they kept hinting at me to photograph them until I was finally watching closely enough to get the message.

In photographing Norbert I was borrowing the idea of capturing an animal in mid-motion from Eadweard Muybridge. In 1878 Muybridge used his camera to prove that horses lift all four legs off the ground at one time as they run. He captured an action that happens too quickly for our minds to grasp what it looks like.

In *Shake*, two photographs of each dog are presented side by side, like two frames of a movie, to show the animal's movement. The photos are a reminder that the external is transitory; that superficial thoughts about the appearance of a person or animal are based on how they look at any one moment, or from different angles. With those we know well, we communicate, relate to each other, and form memories based on common appearances and expressions. When we take a familiar smile away, our minds are left searching for an explanation. *Shake* calls us to challenge our understanding of the familiar.

The images are not meant to be overtly funny, but the photographs certainly make me laugh. The concept is not meant to be dark, and yet by capturing awkward expressions, some of the photos make the dogs look more like monsters than the friends we see every day.

After photographing the first five dogs in the series, I posted the photos online. *Shake* quickly went viral and took over my life like a storm. My work was appearing in blogs and was being published in magazines. It was being reviewed by people I had only dreamed would ever pay attention to me and my off-the-cuff photos. During a global recession and war, a time when conversations were sad and heavy, I was receiving hundreds of e-mails a week from people telling me my photos made them laugh, and that felt amazing. Seeing how *Shake* was shared and enjoyed by millions of people worldwide has given me insight into the universality of how much we love our pets, and how excited we are to see our heroes in a new way.

—*Carli Davidson*

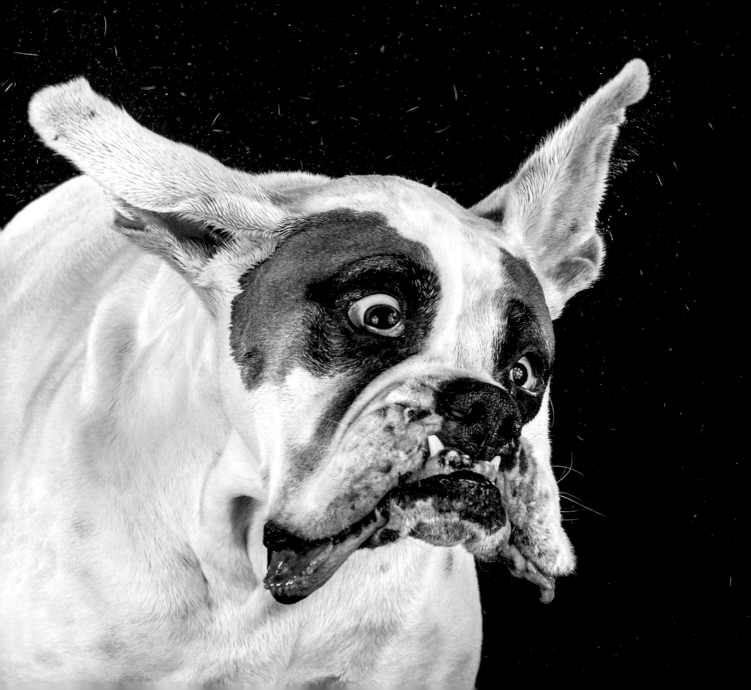

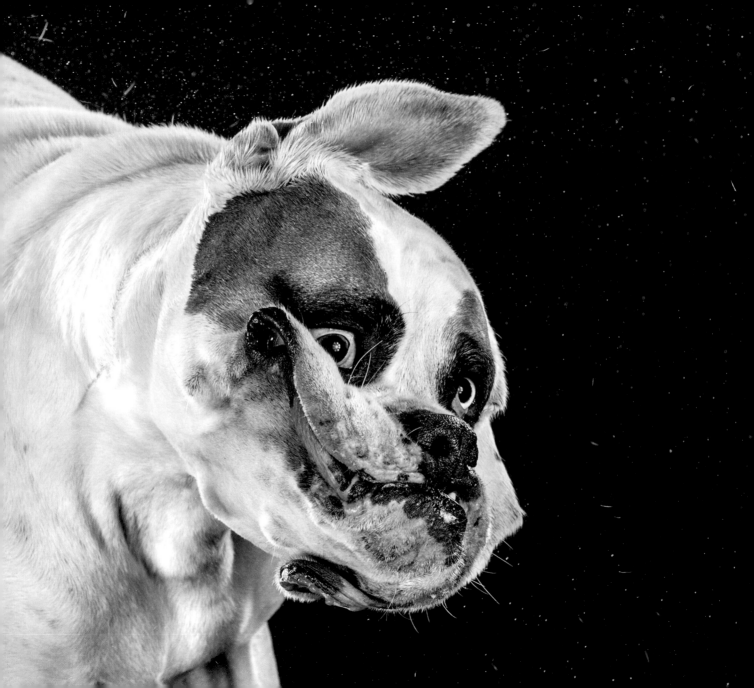

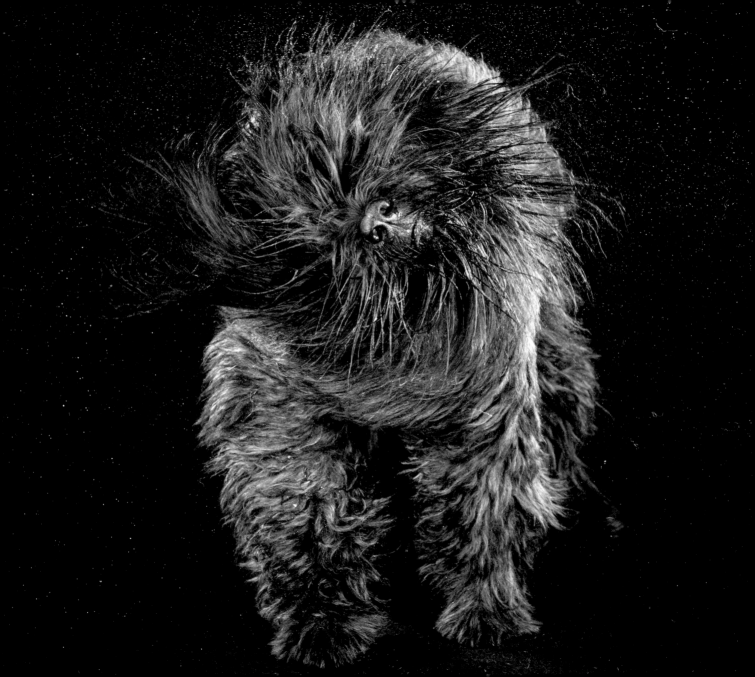

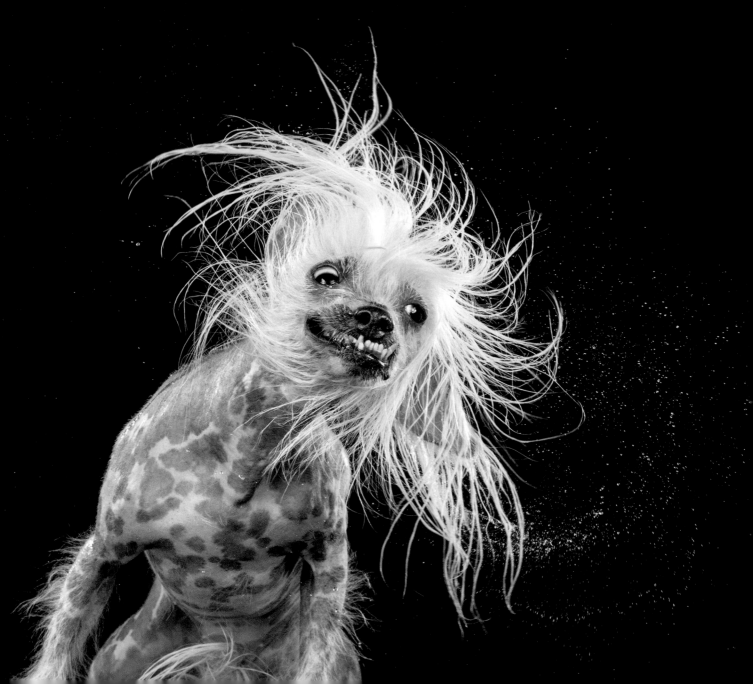

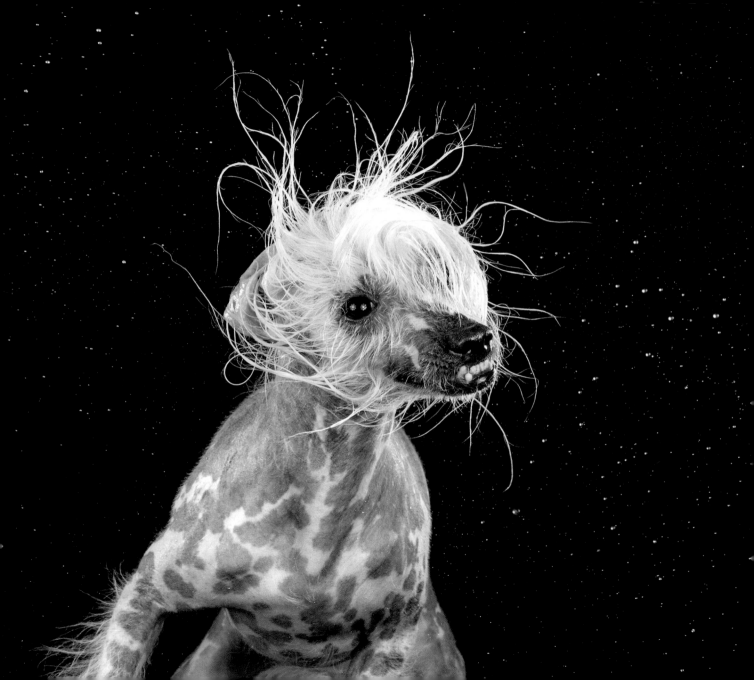

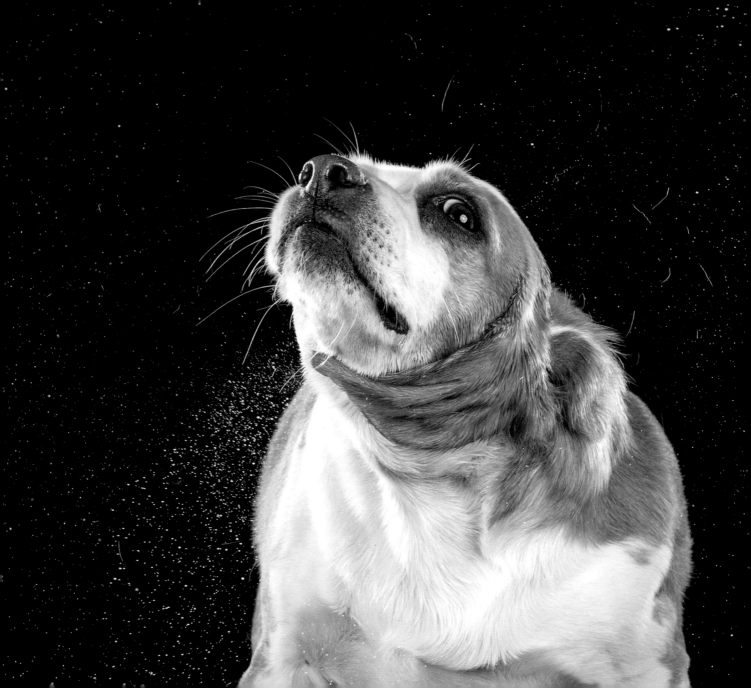

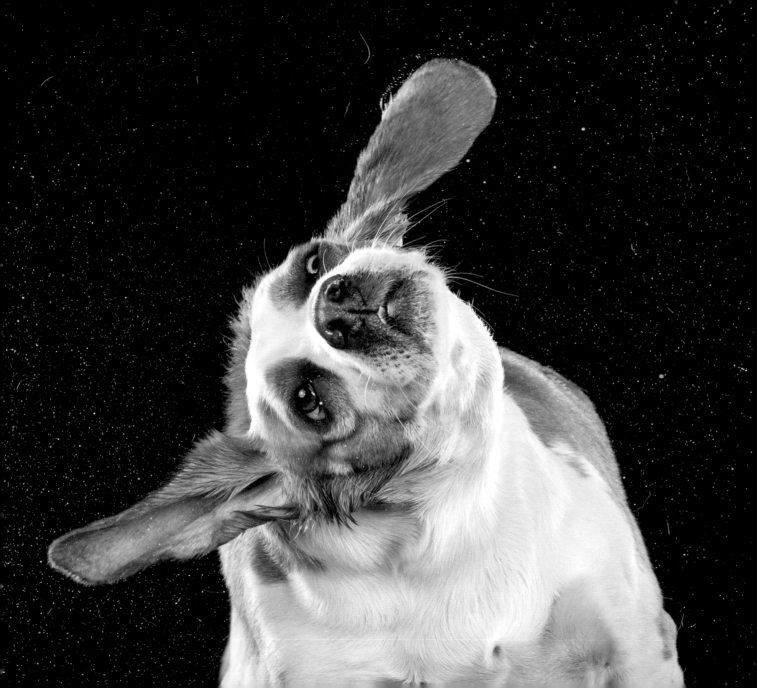

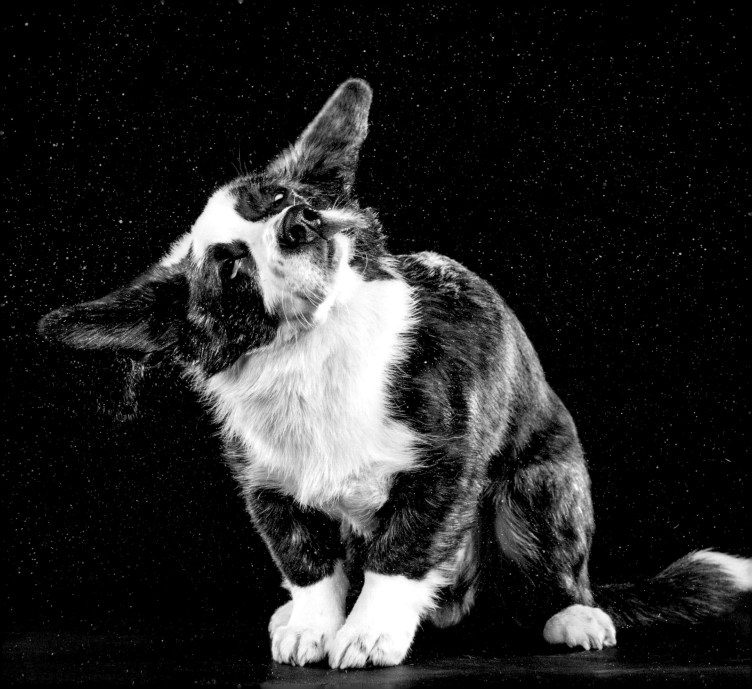

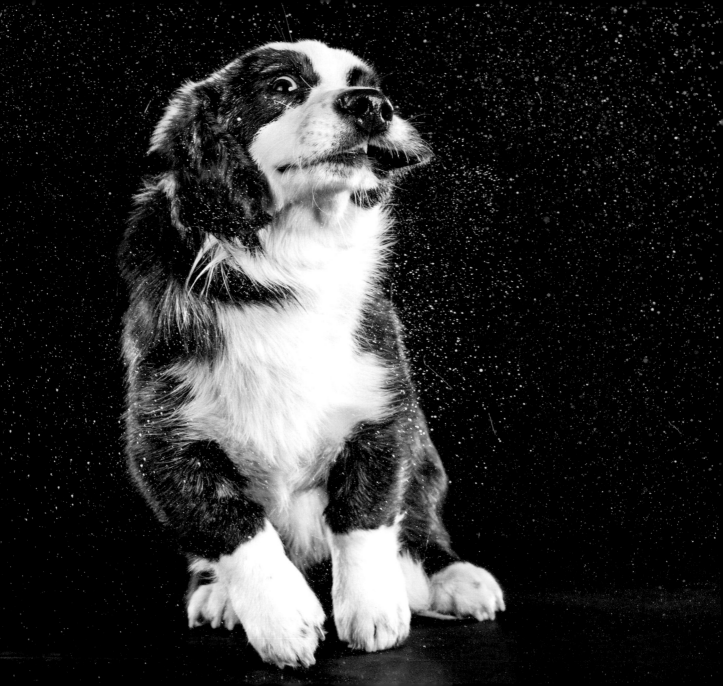

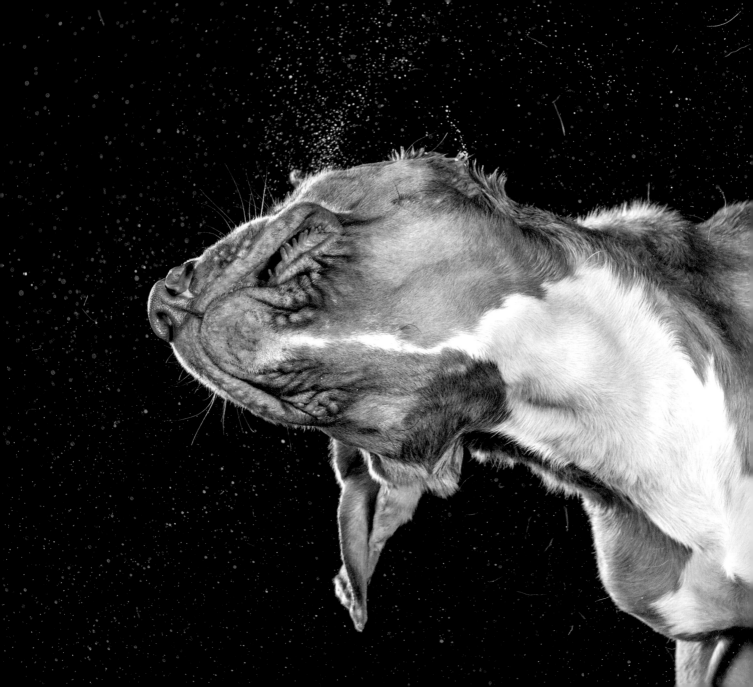

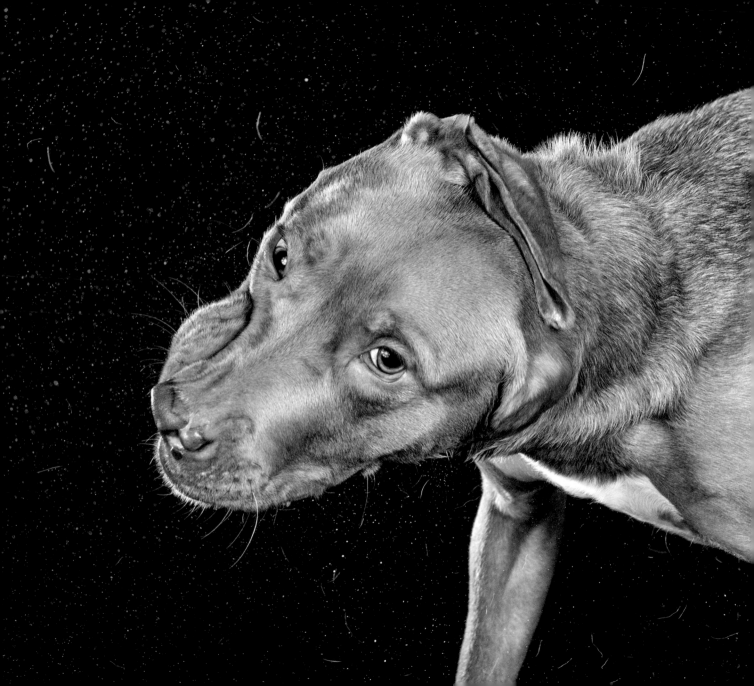

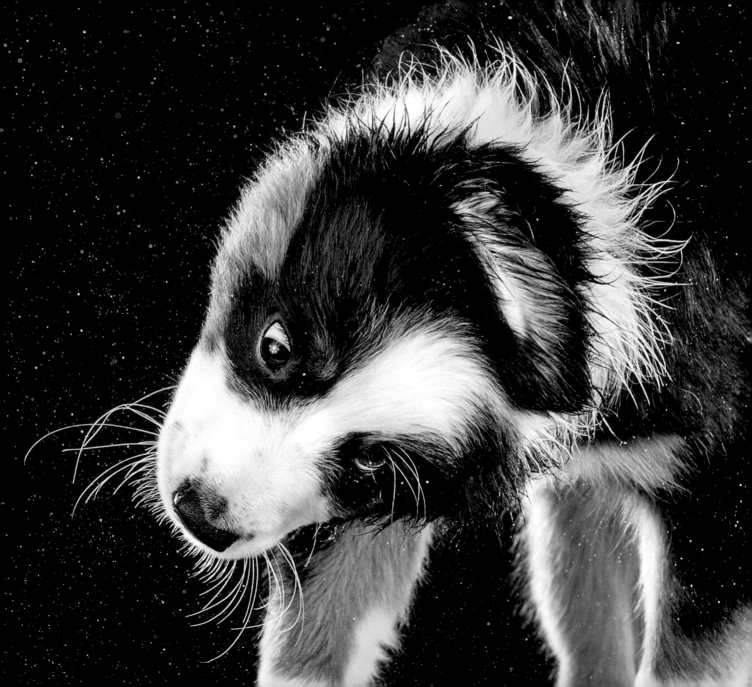

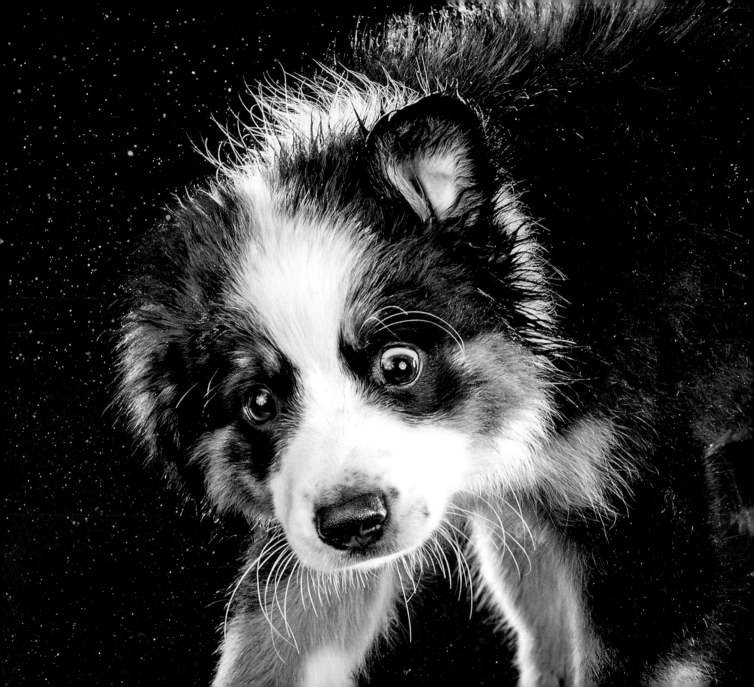

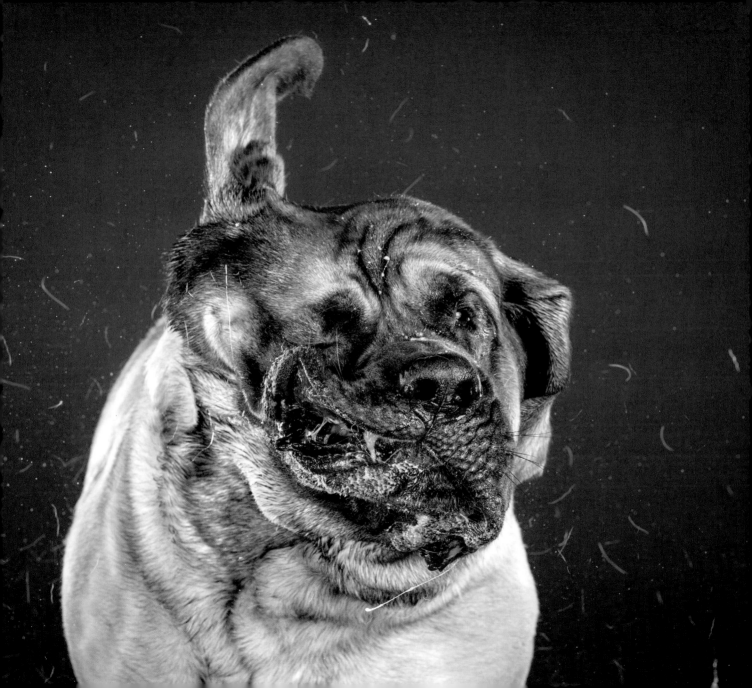

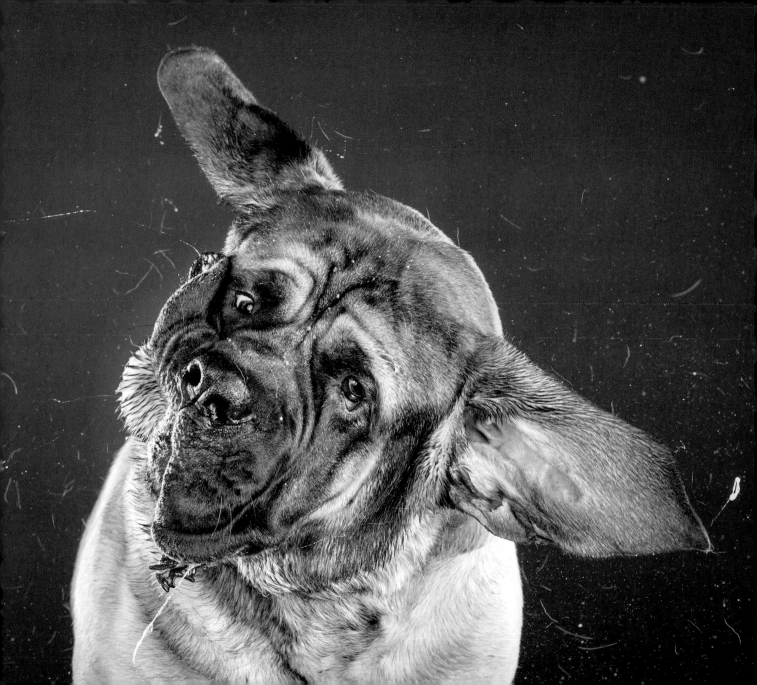

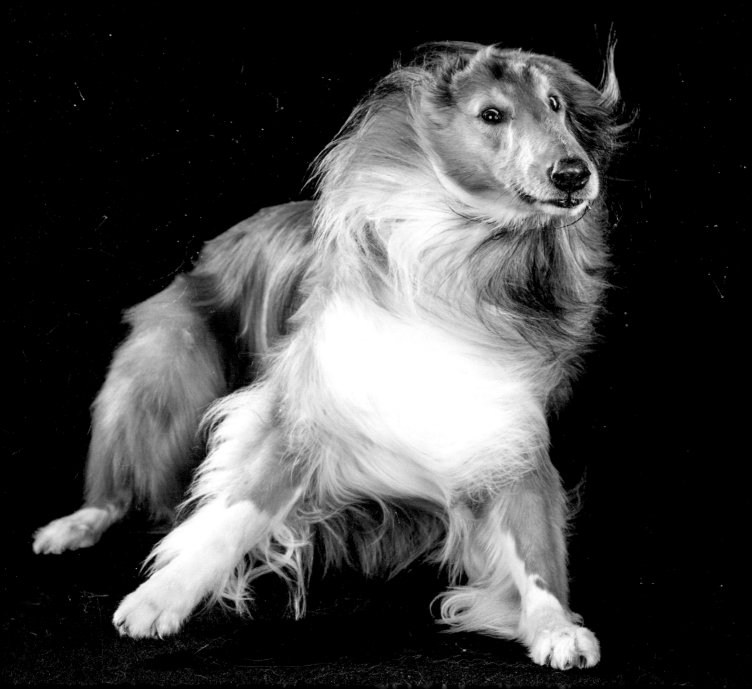

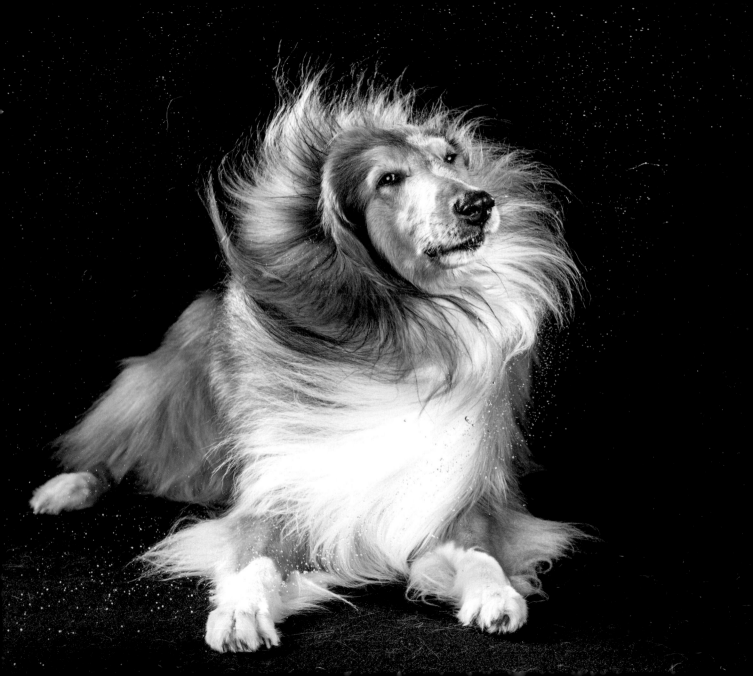

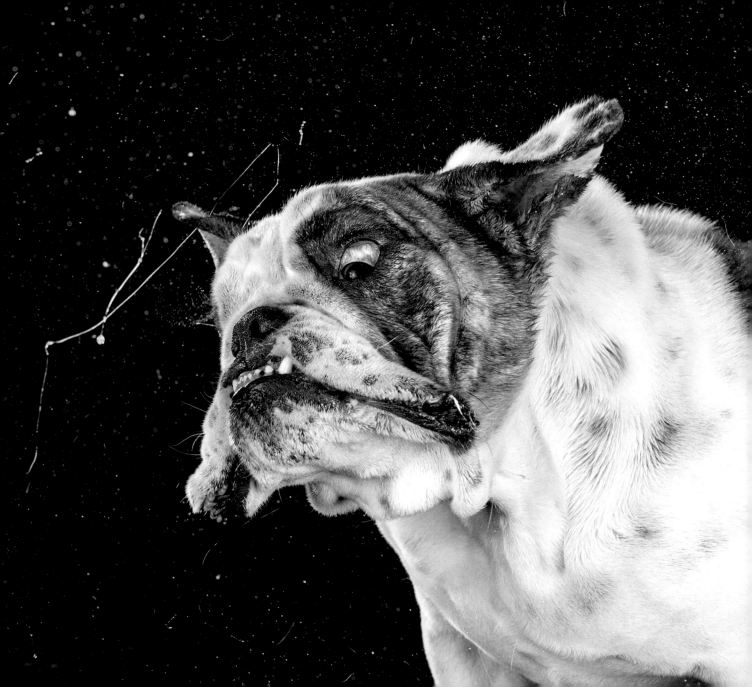

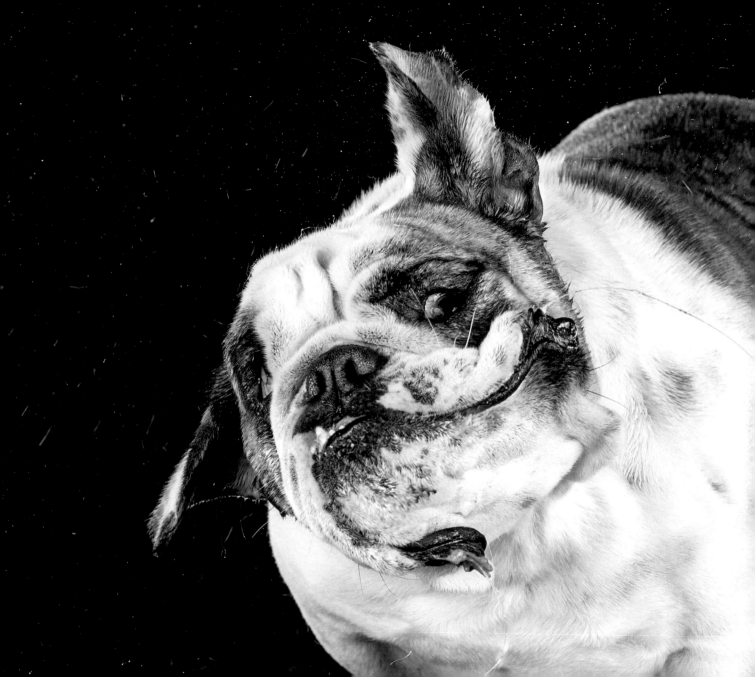

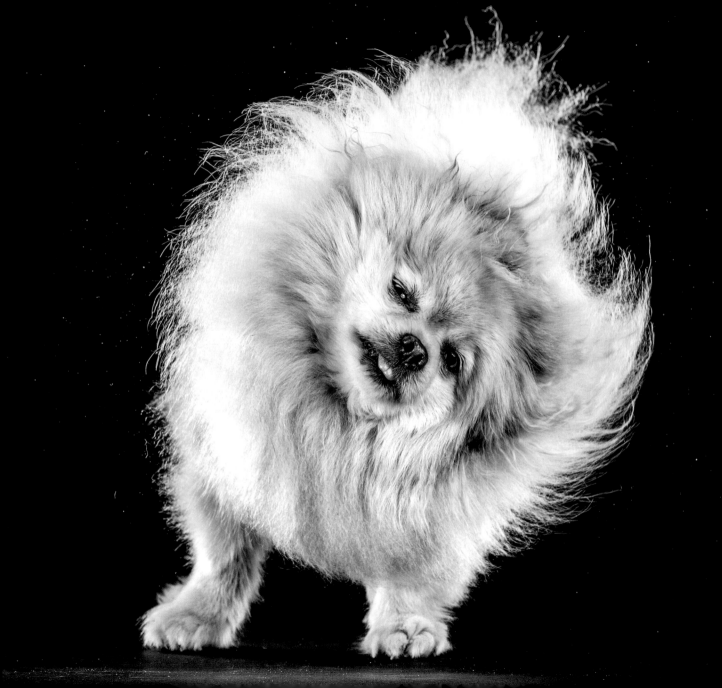

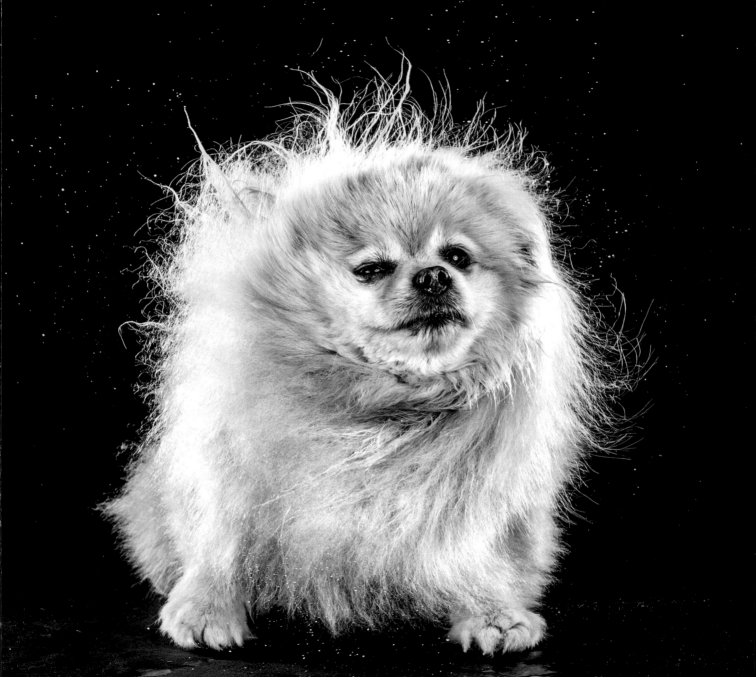

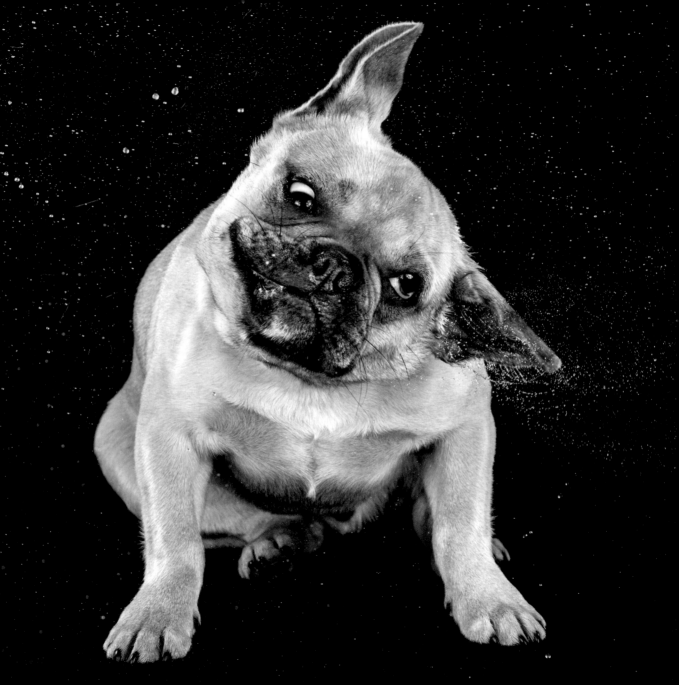

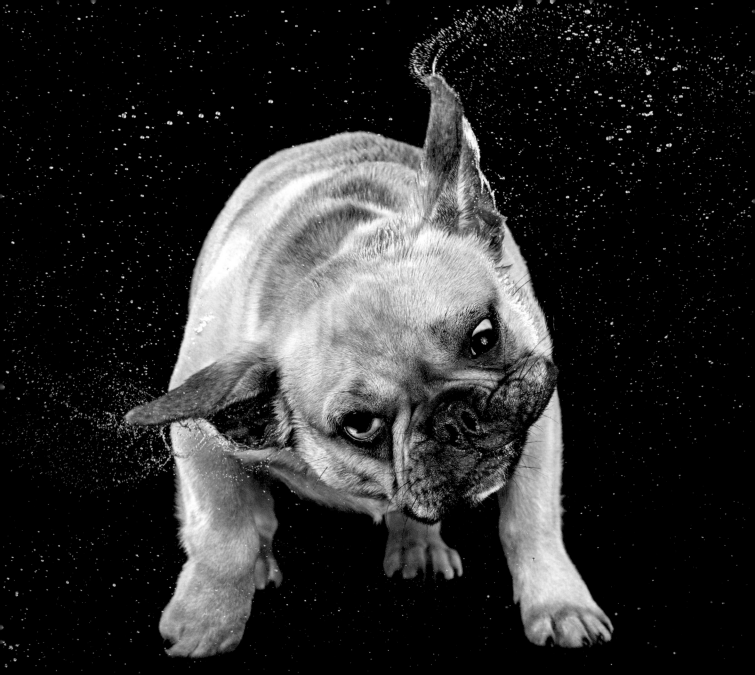

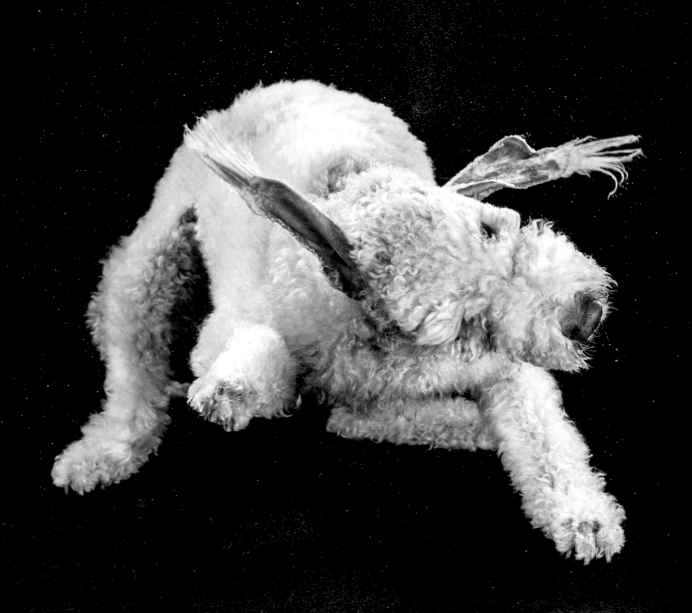

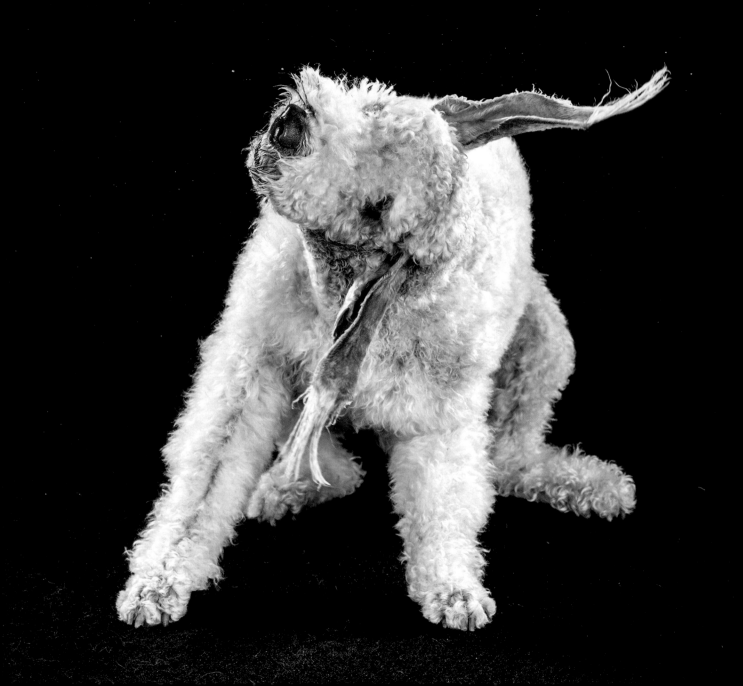

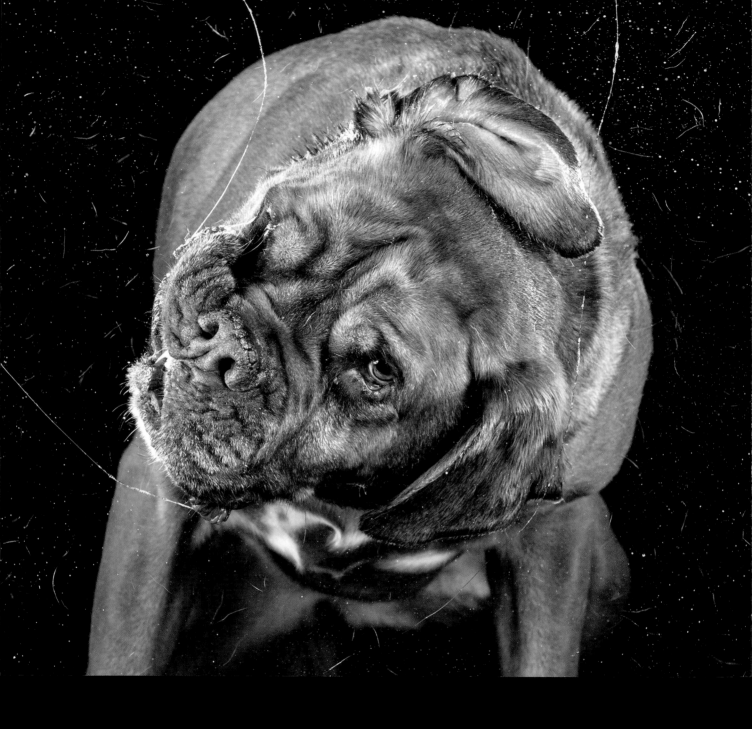

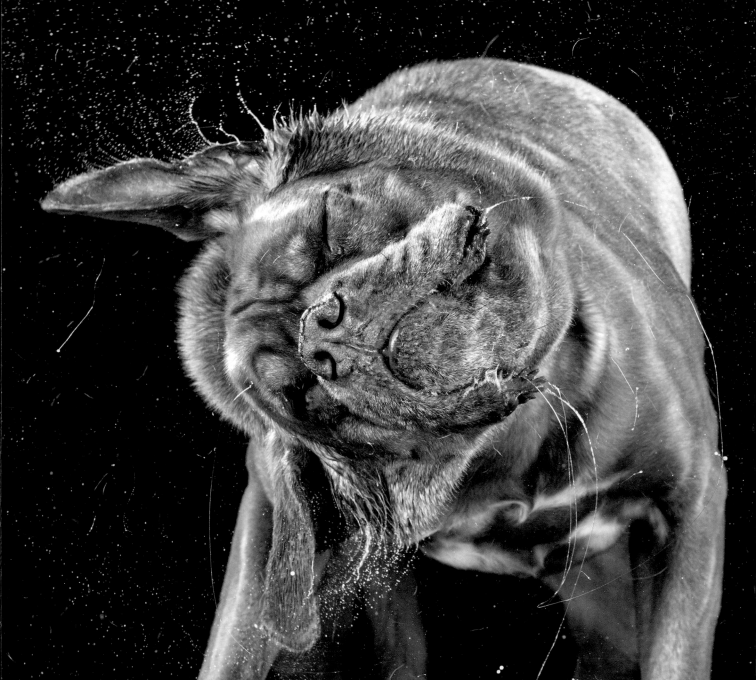

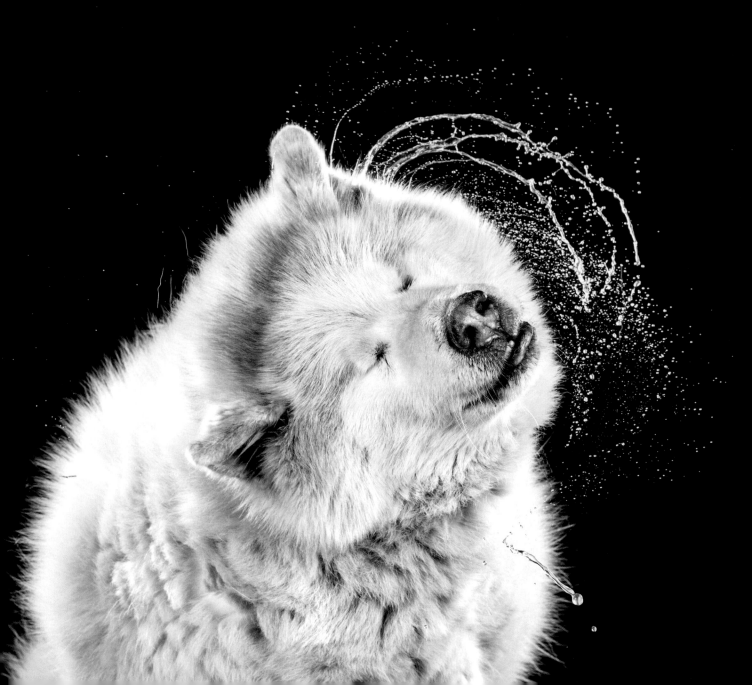

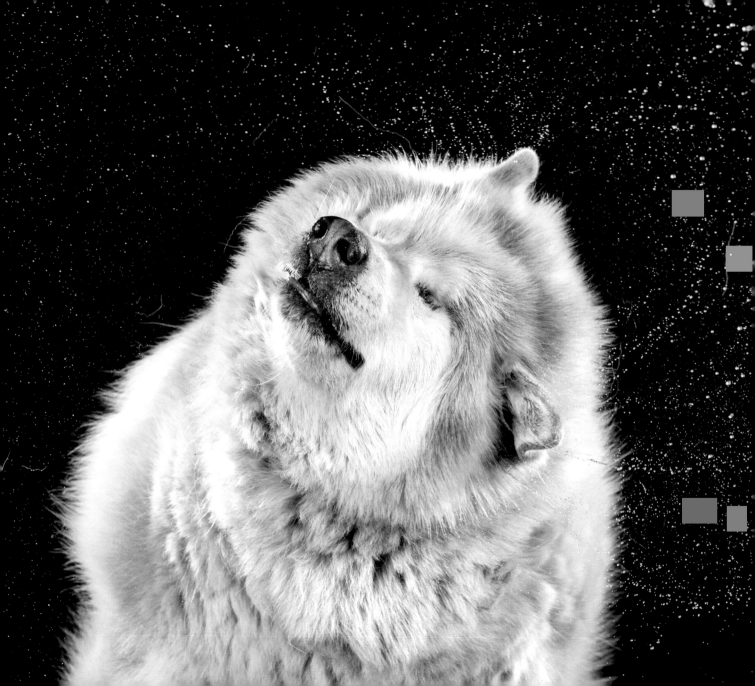

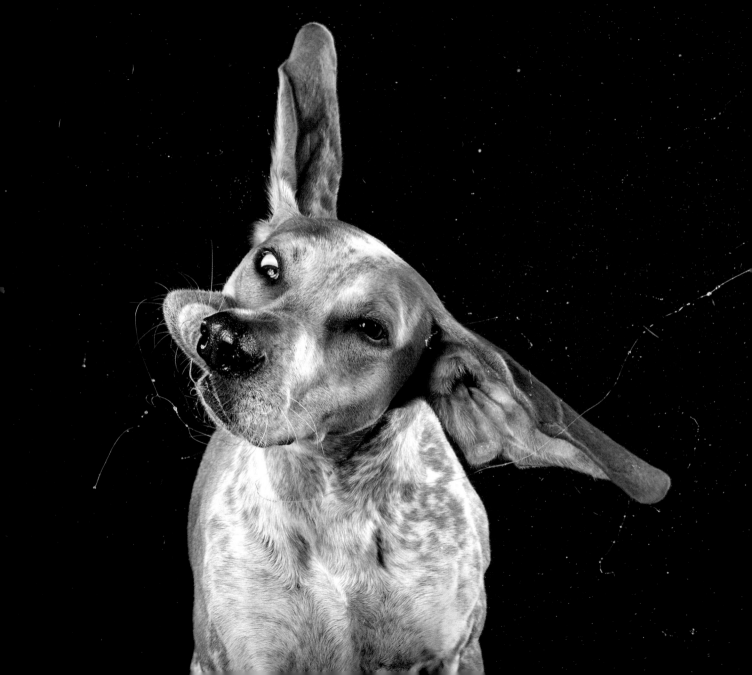

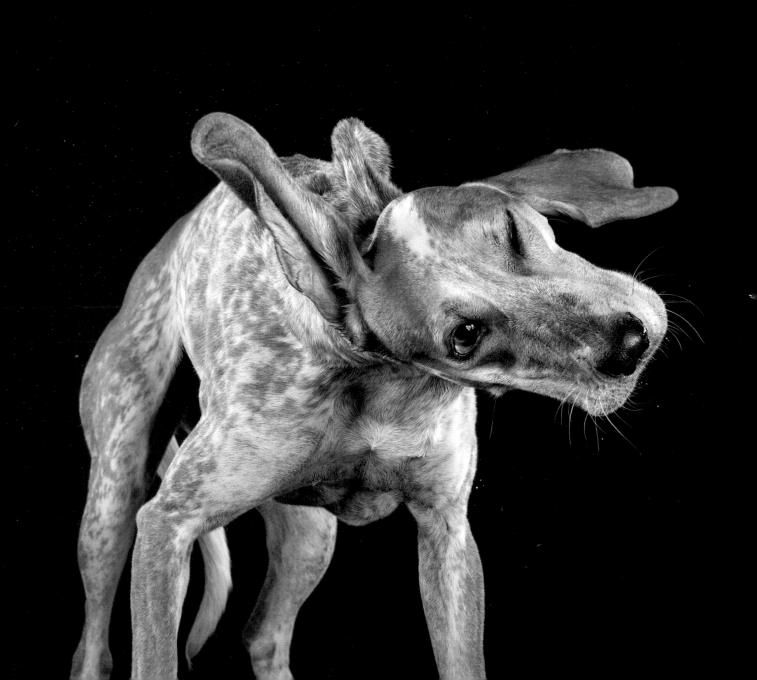

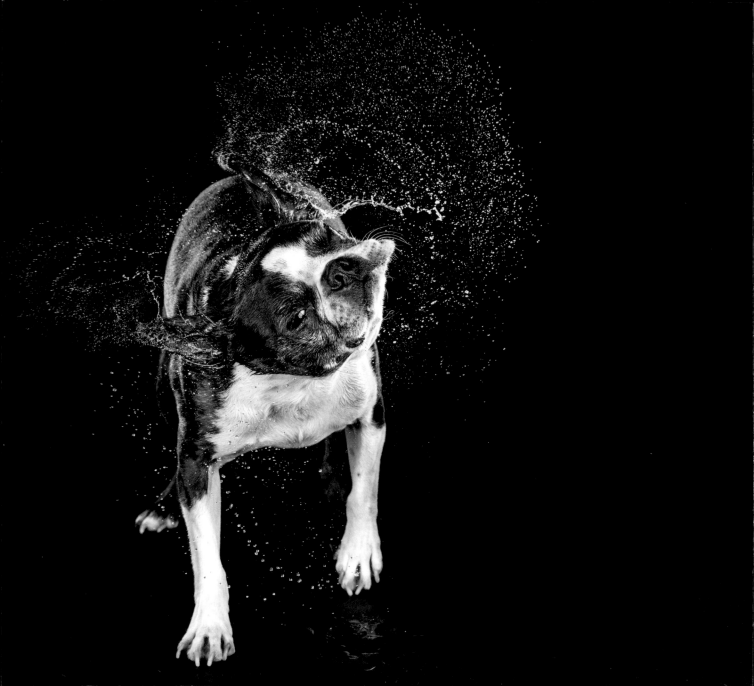

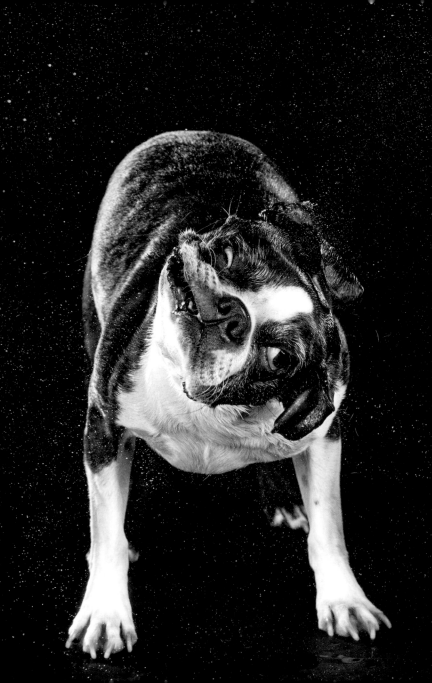

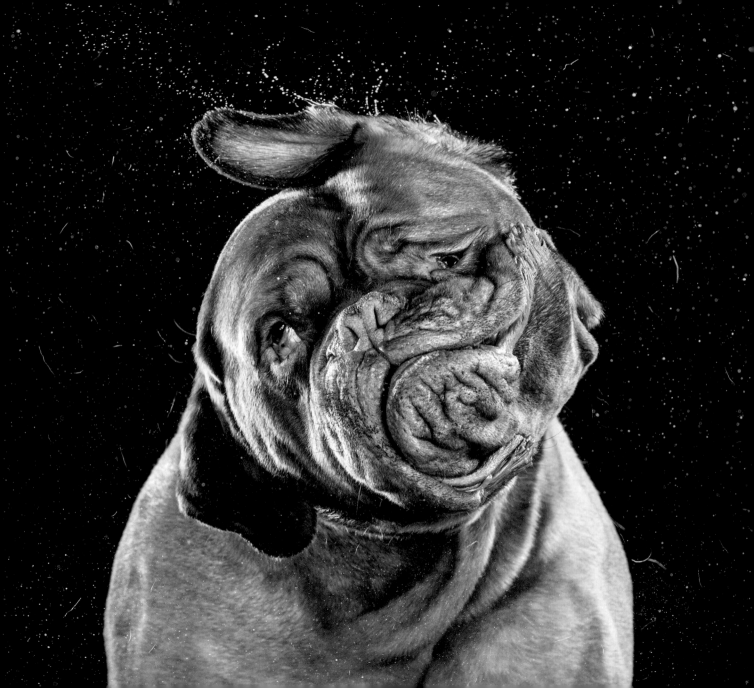

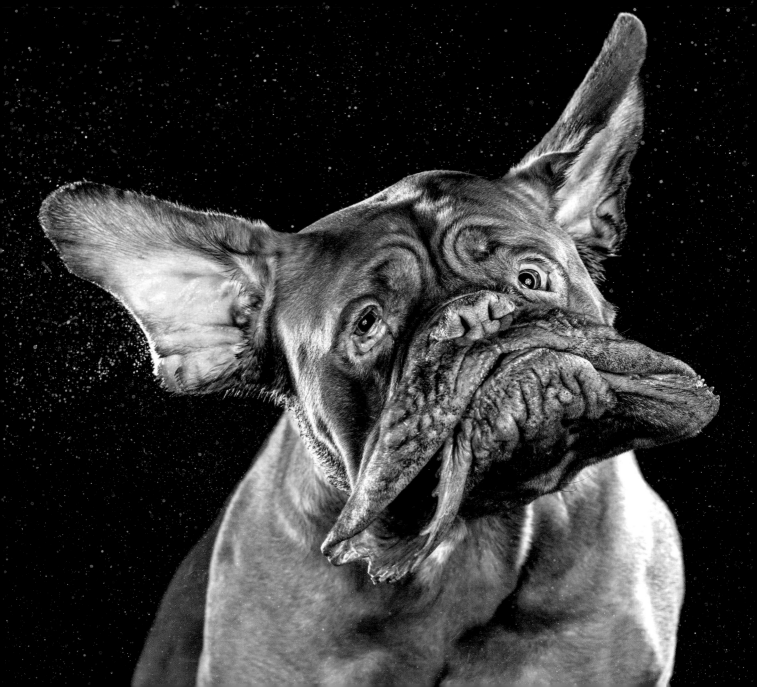

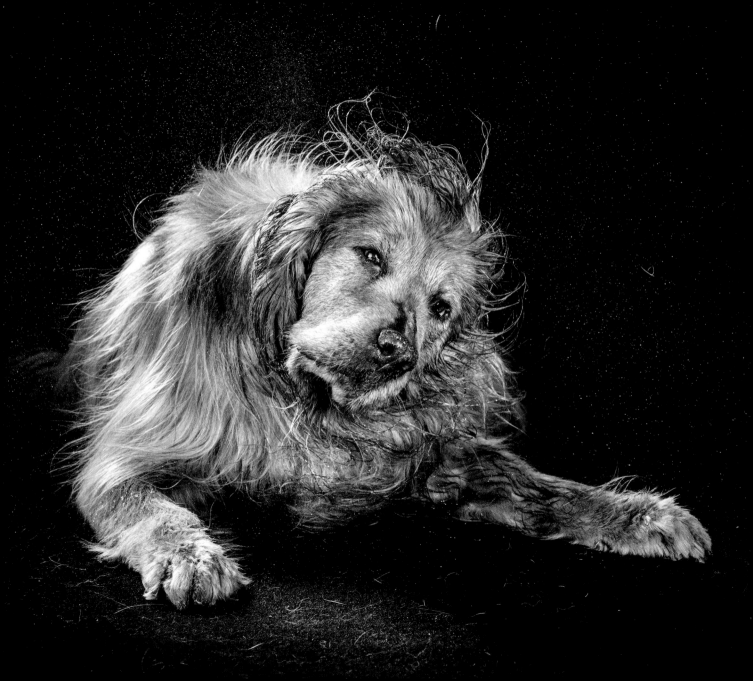

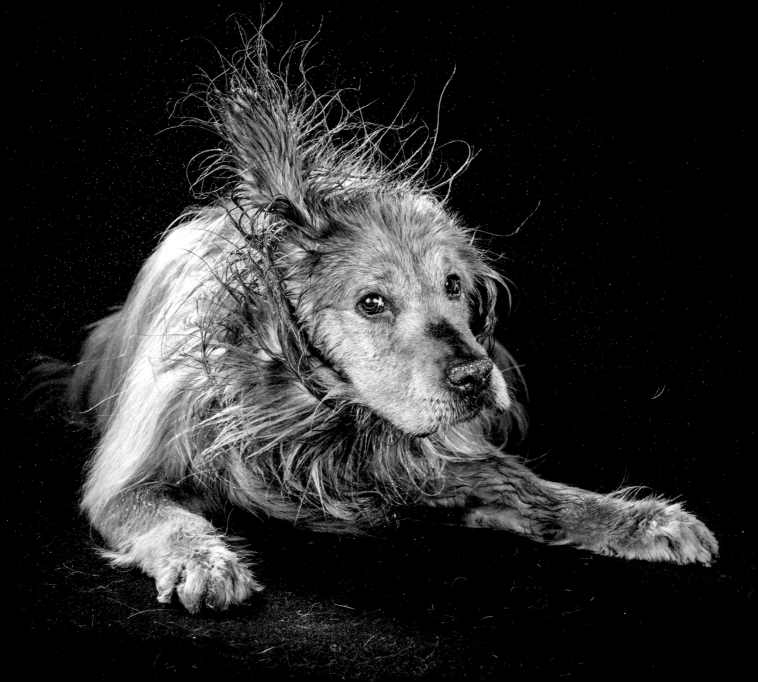

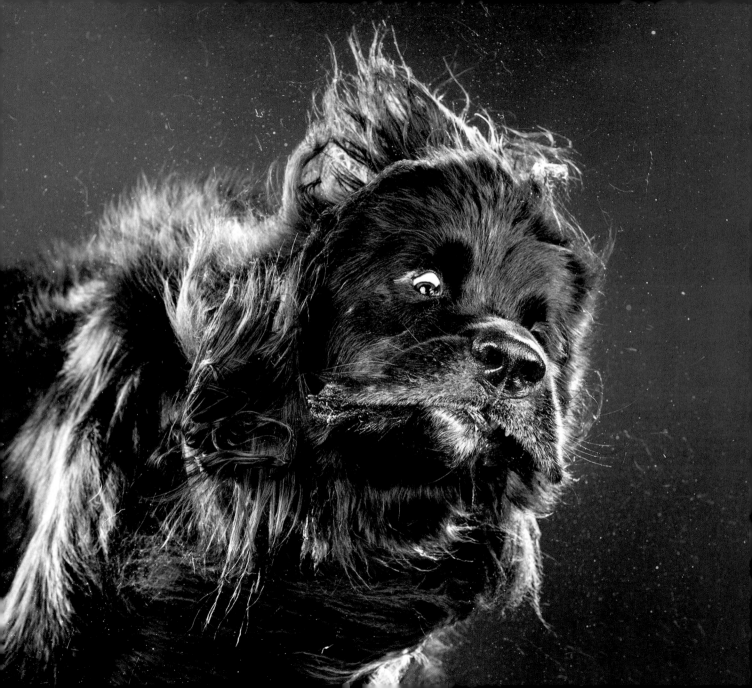

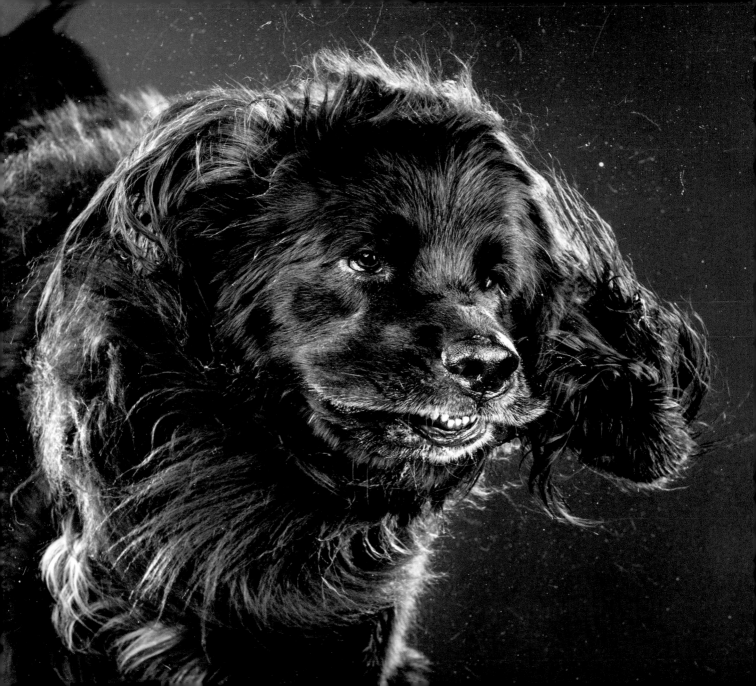

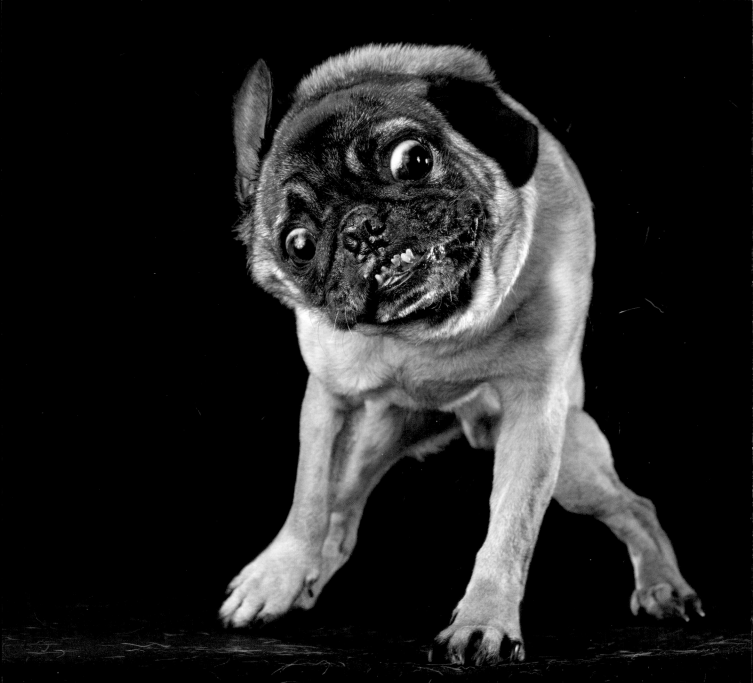

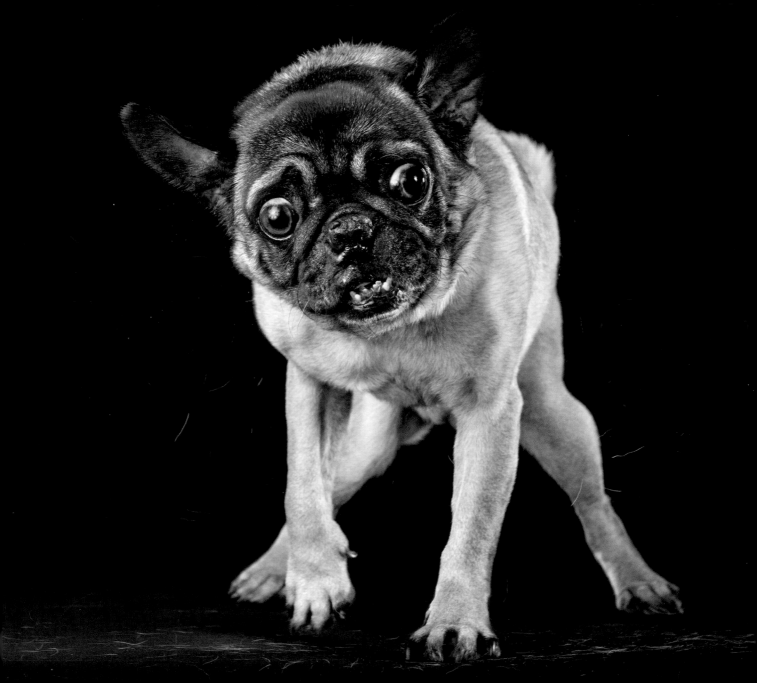

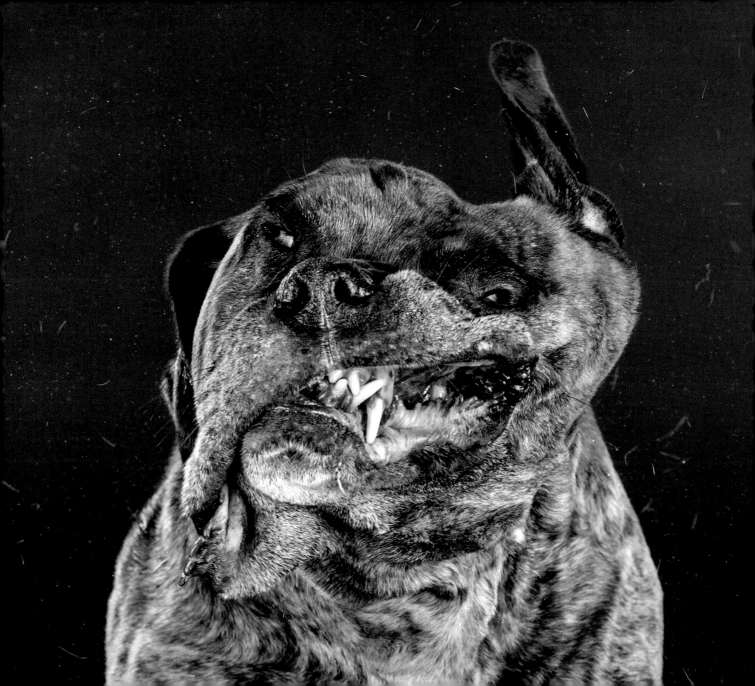

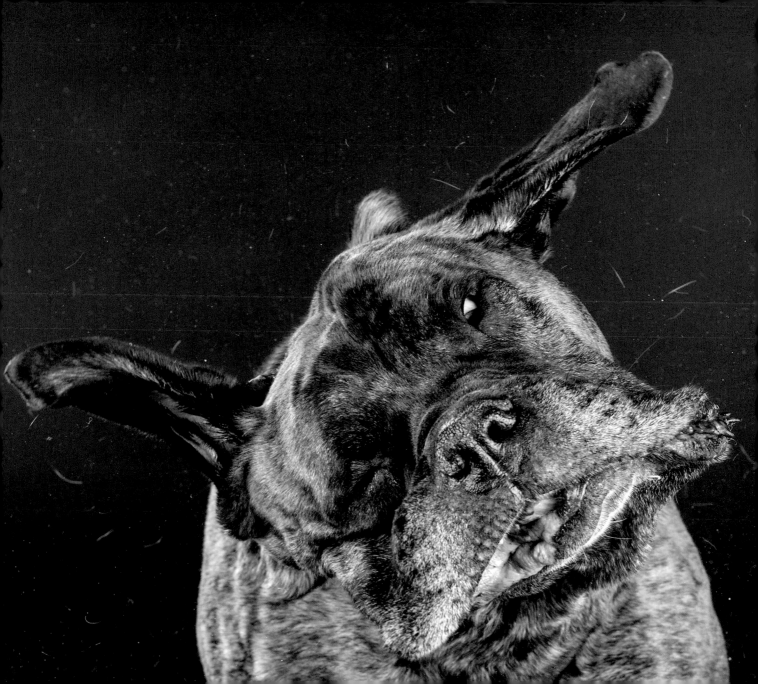

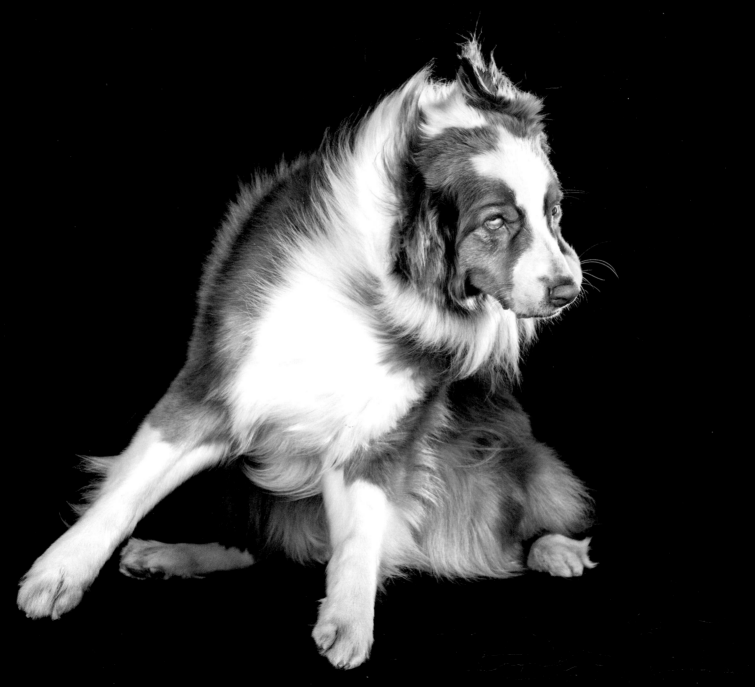

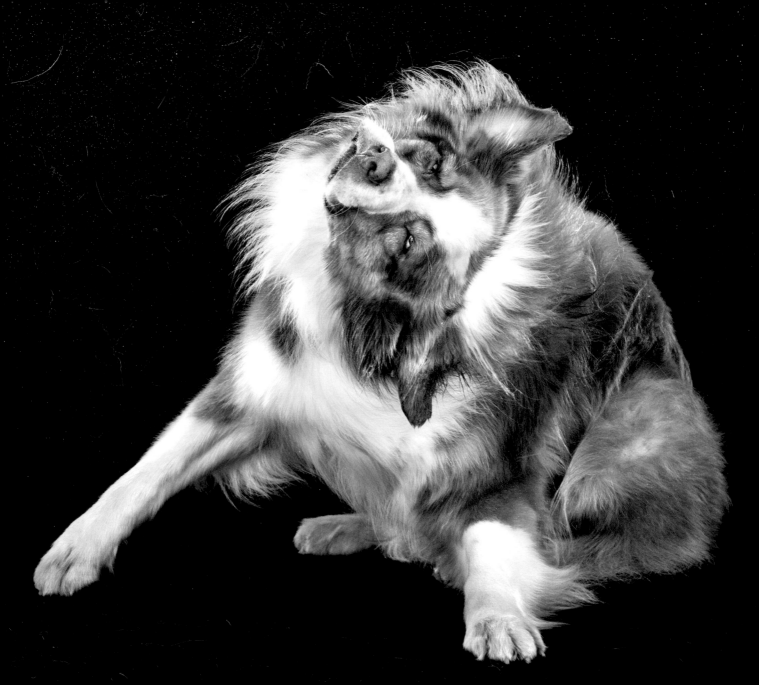

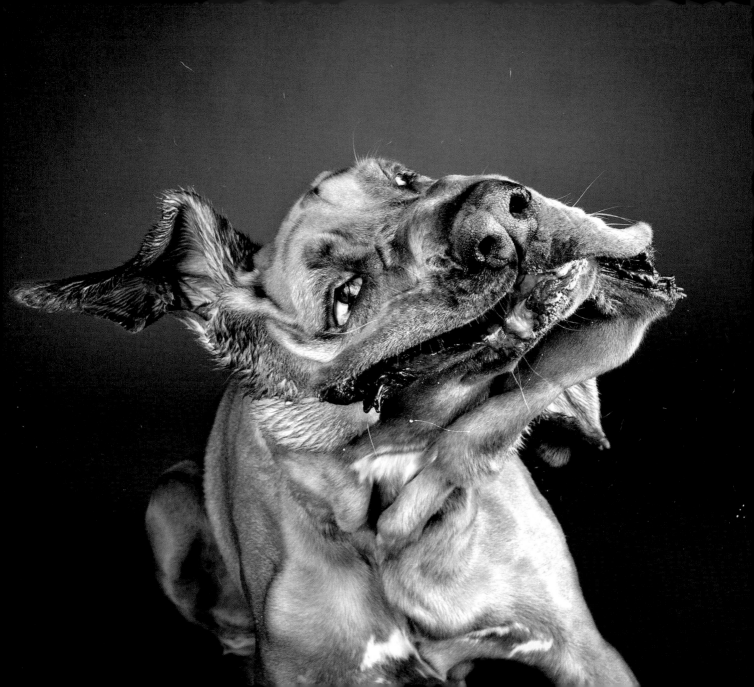

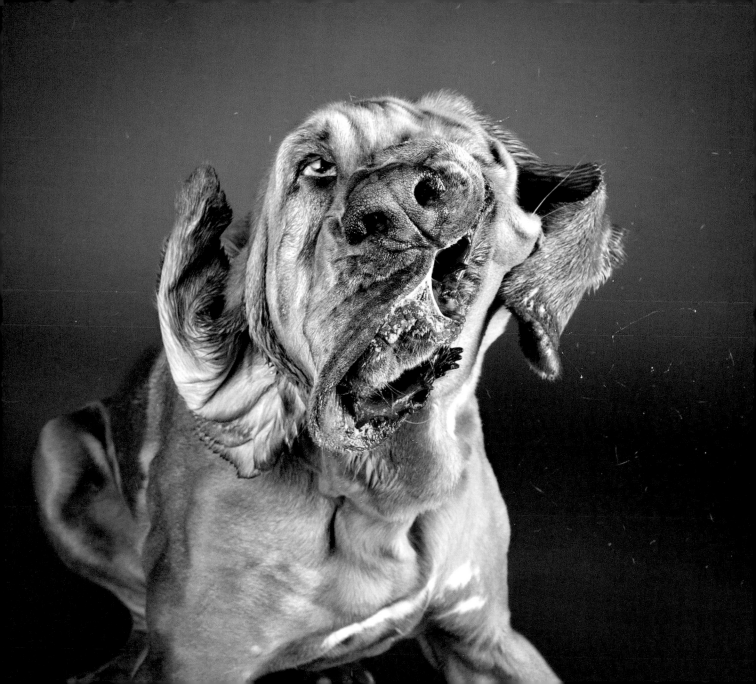

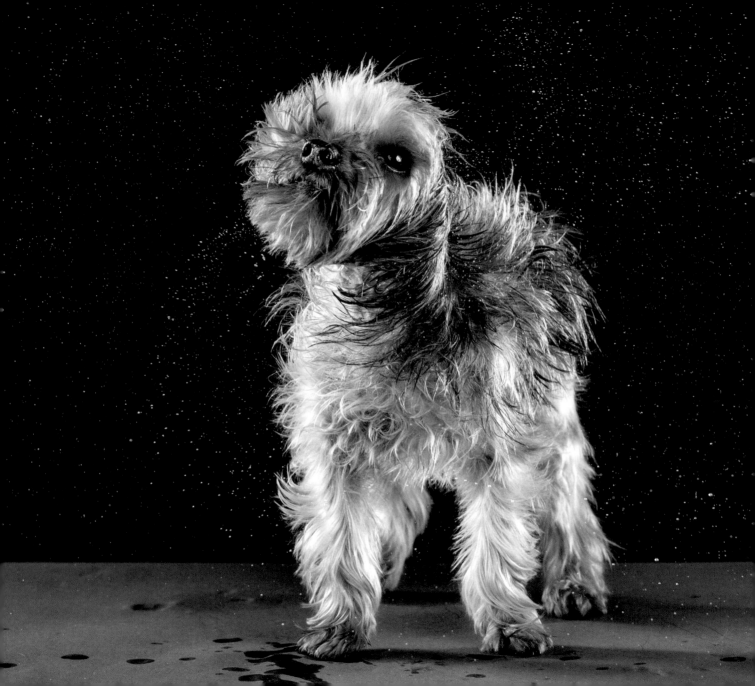

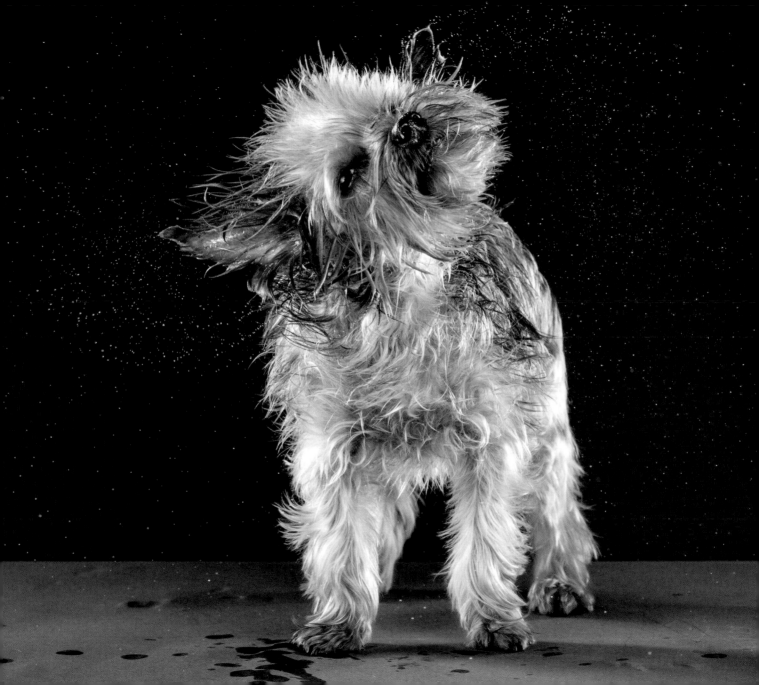

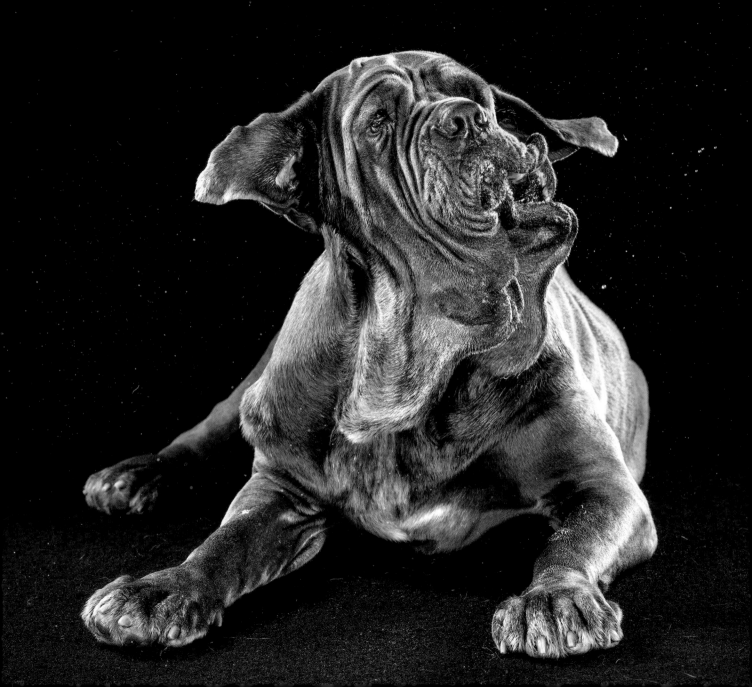

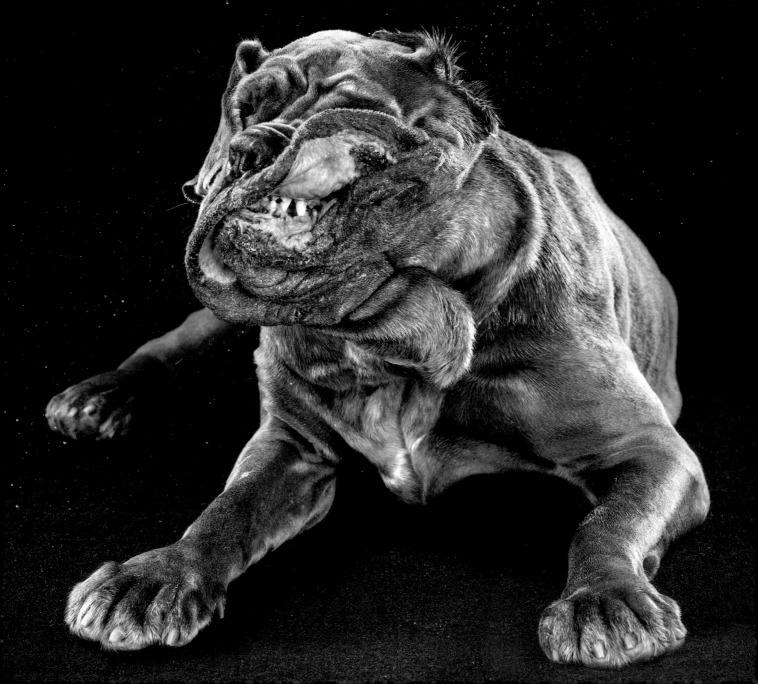

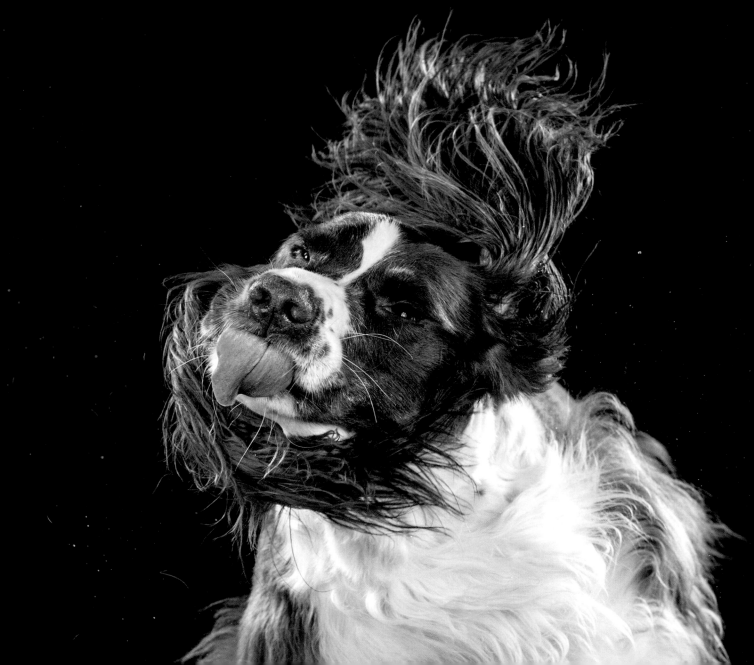

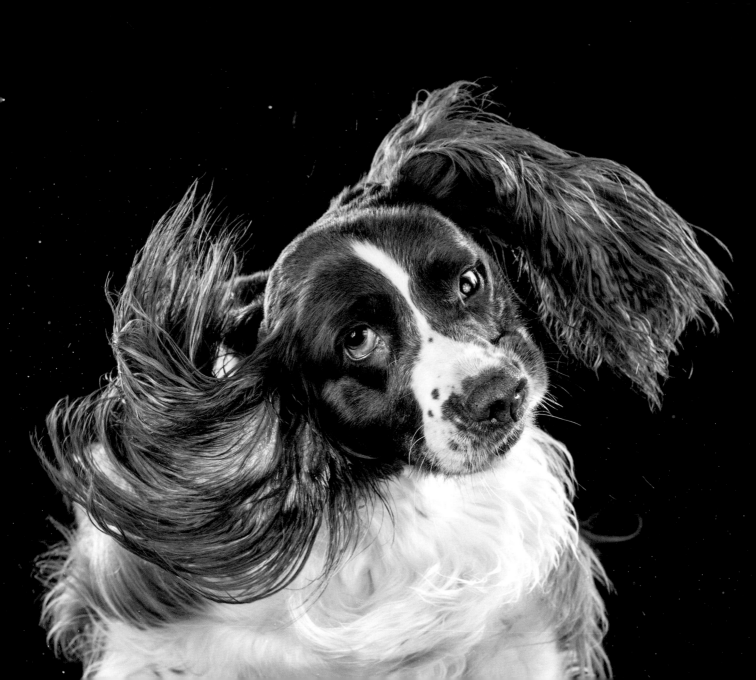

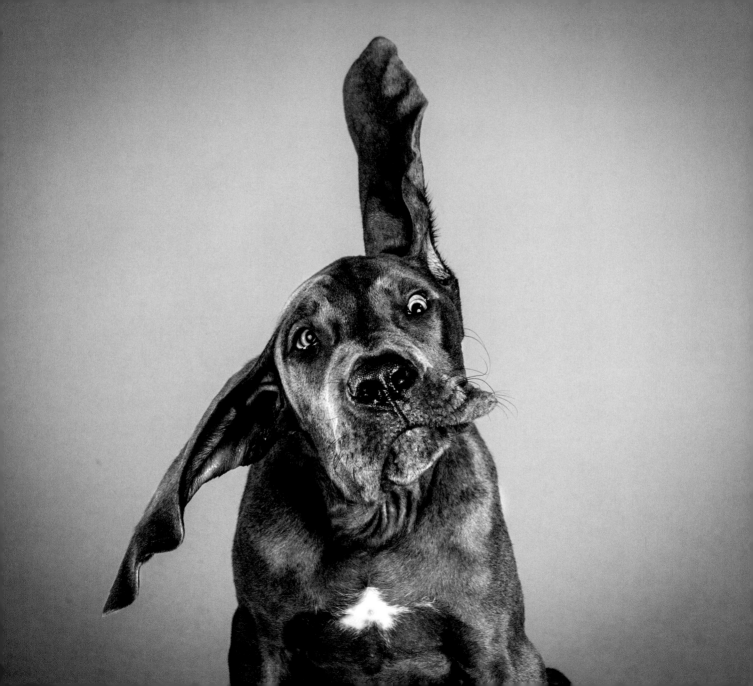

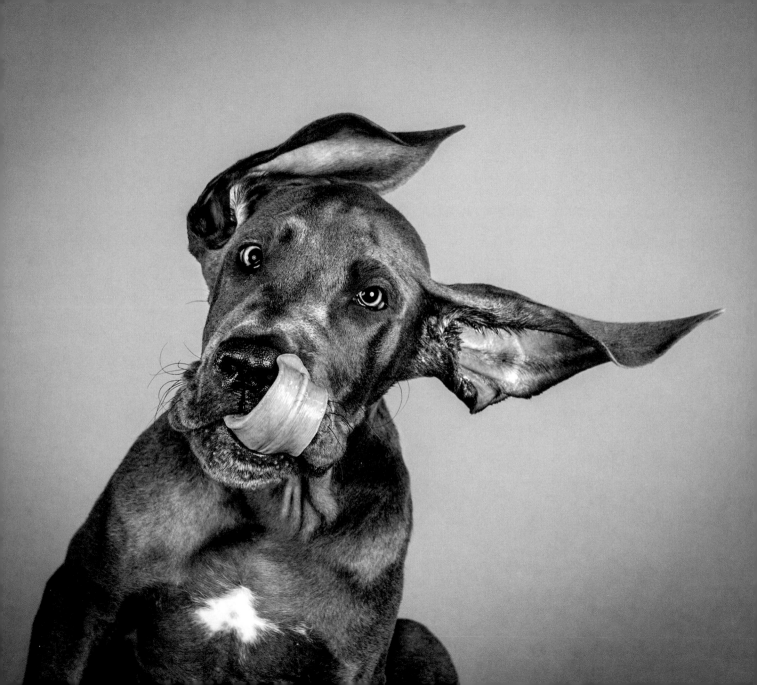

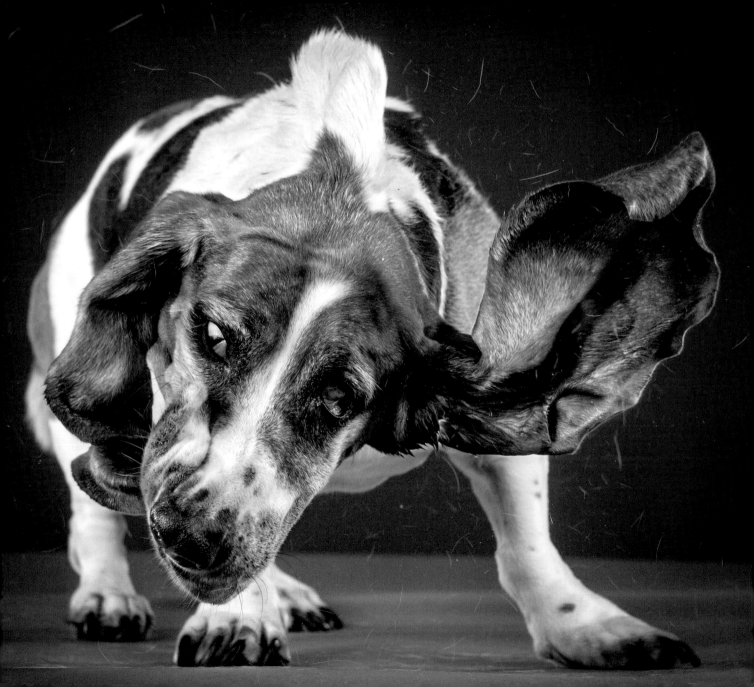

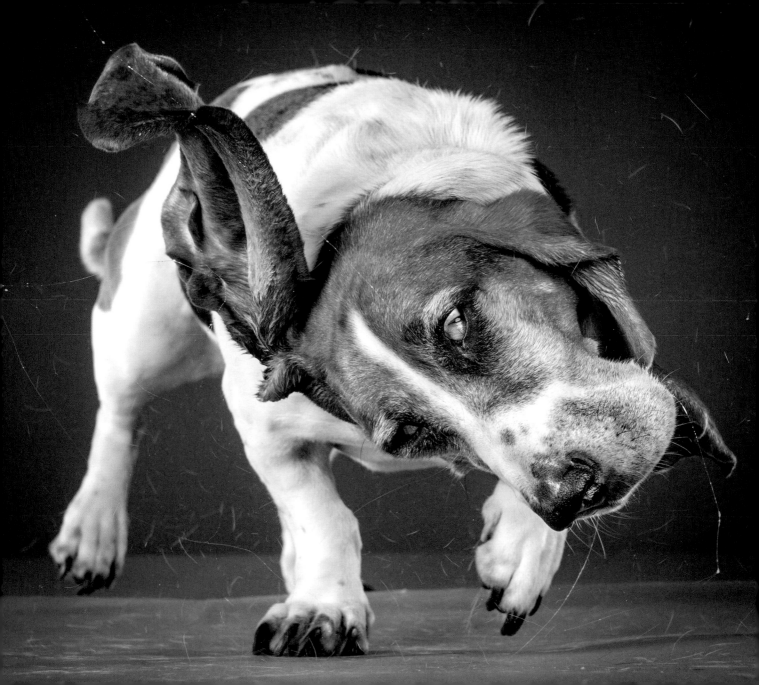

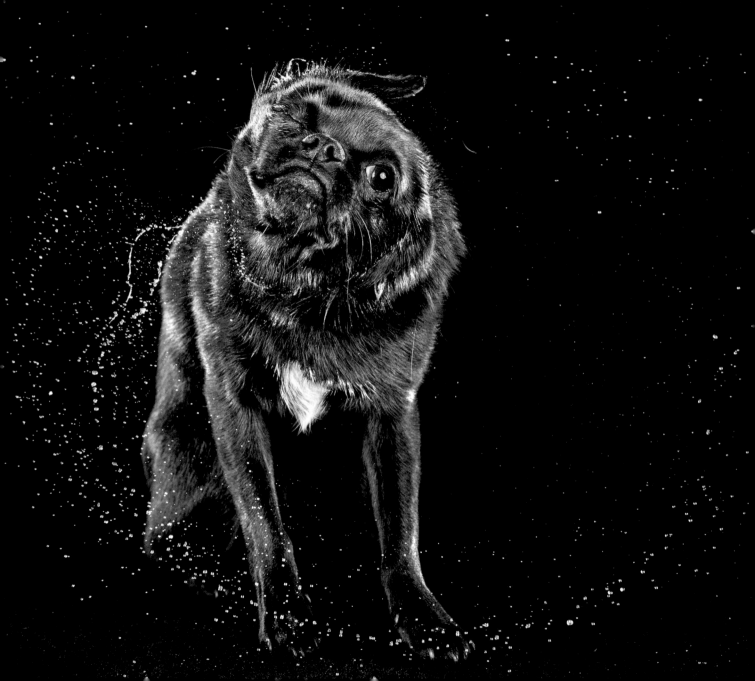

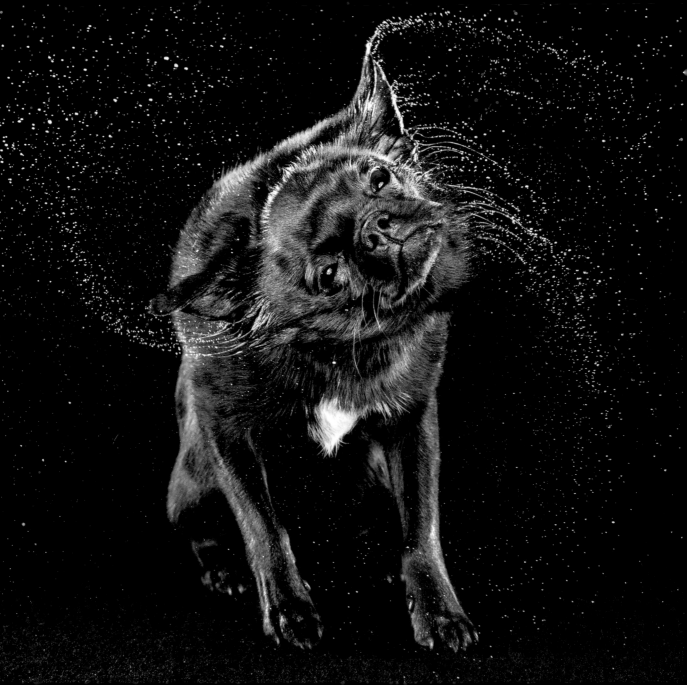

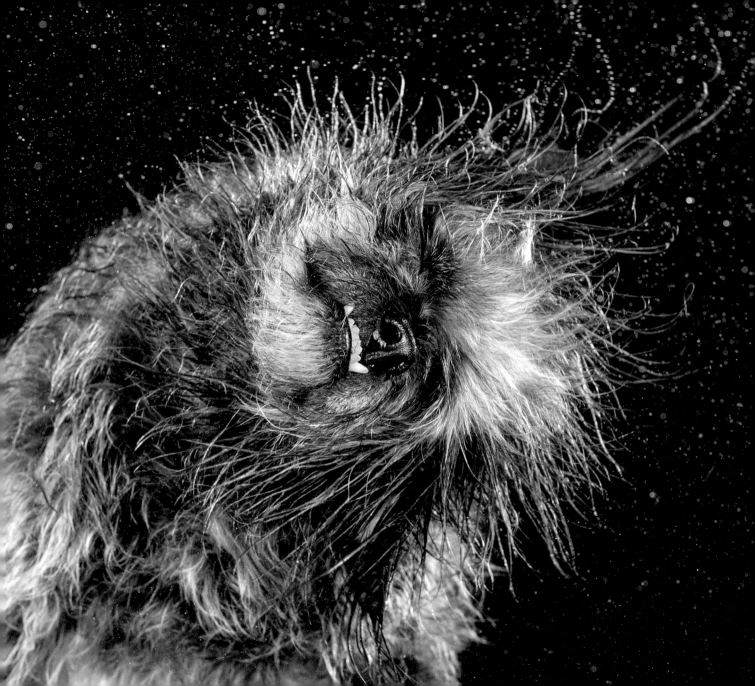

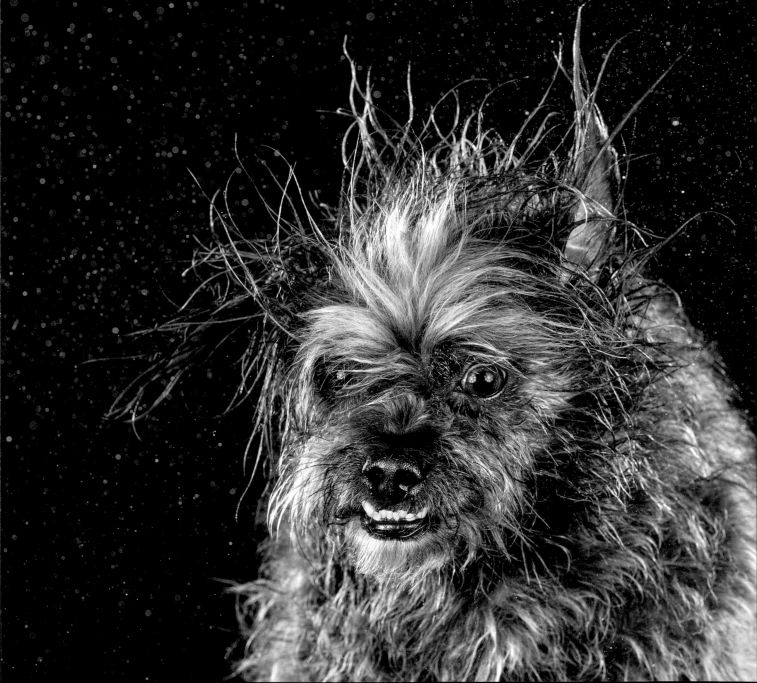

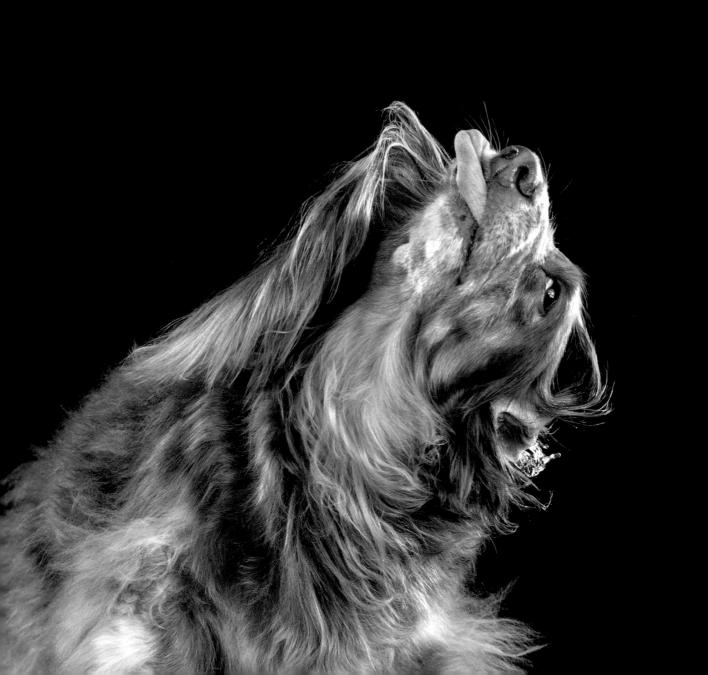

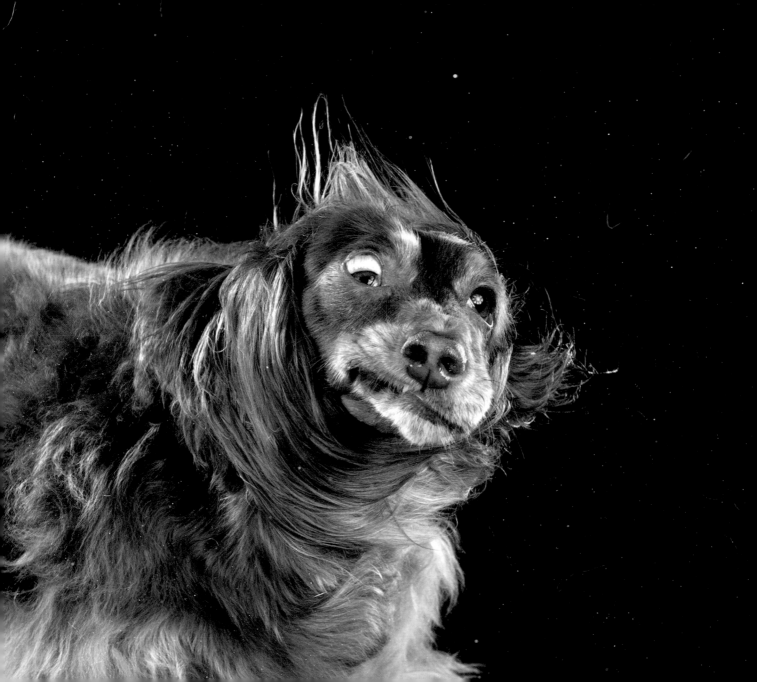

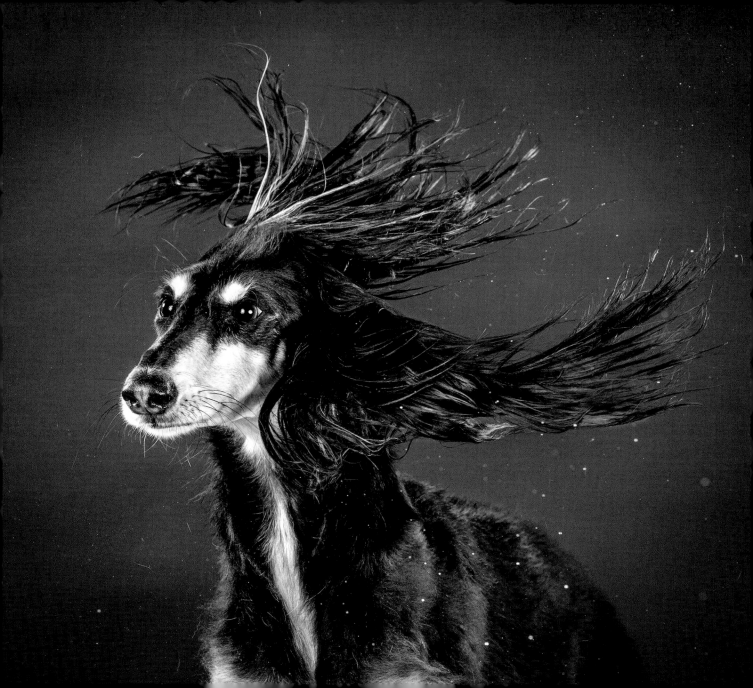

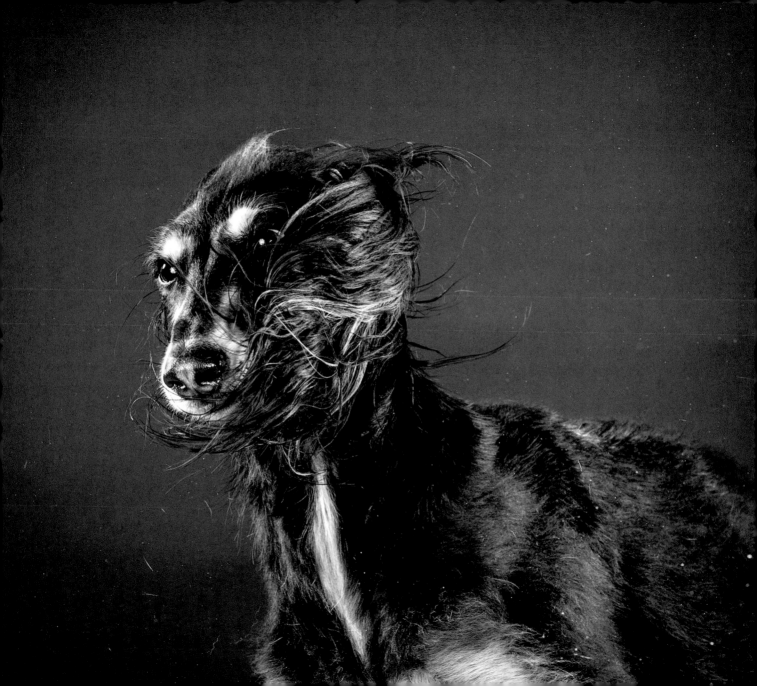

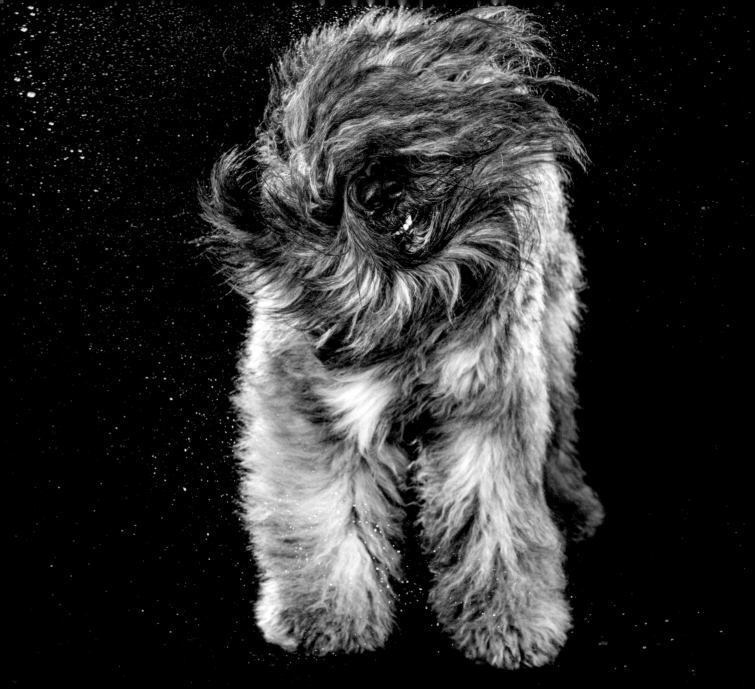

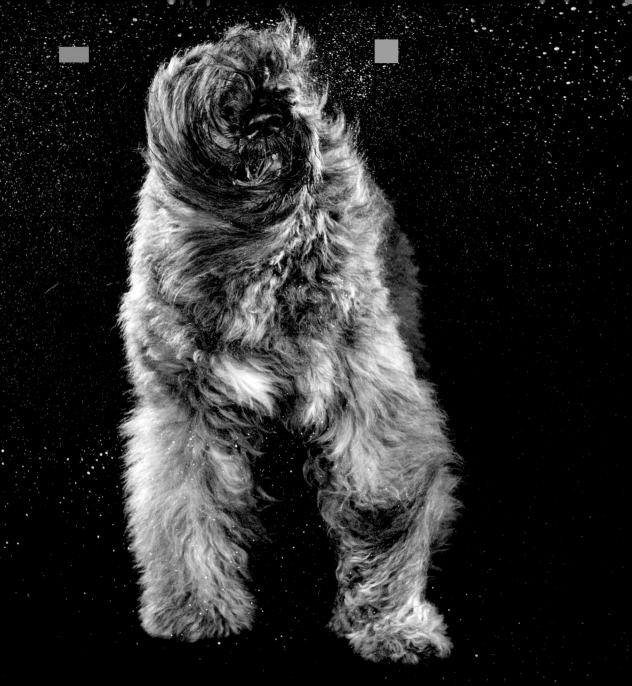

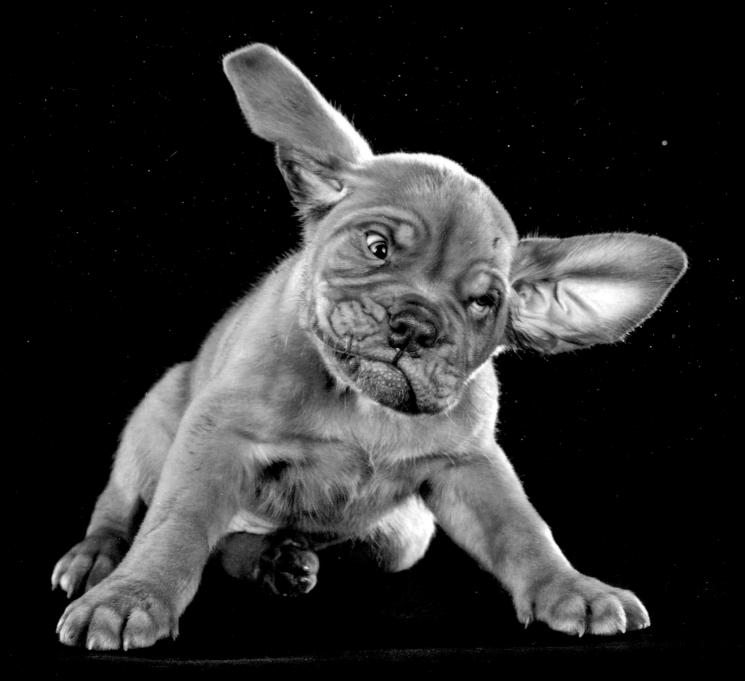

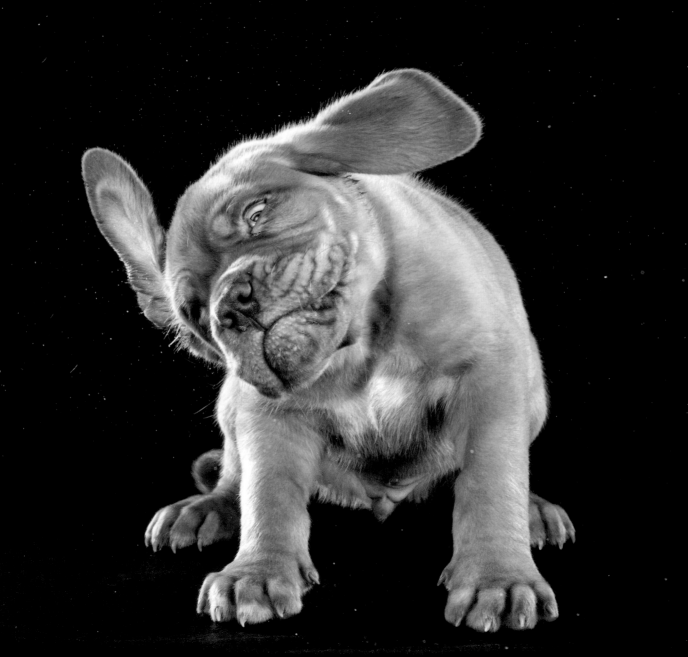

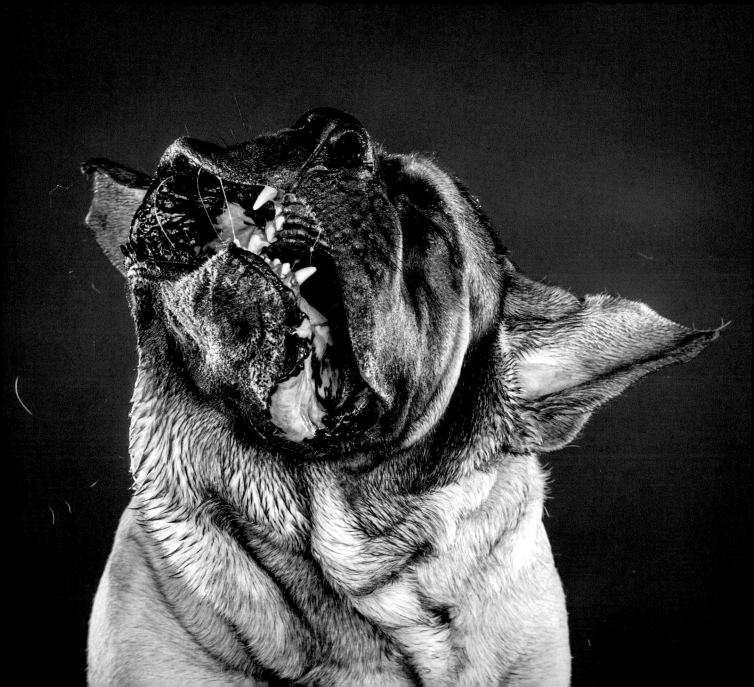

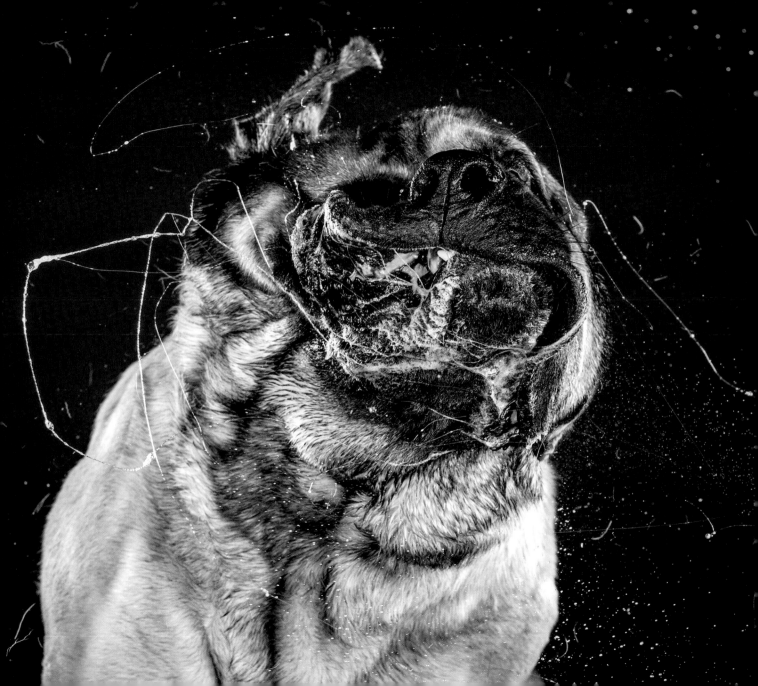

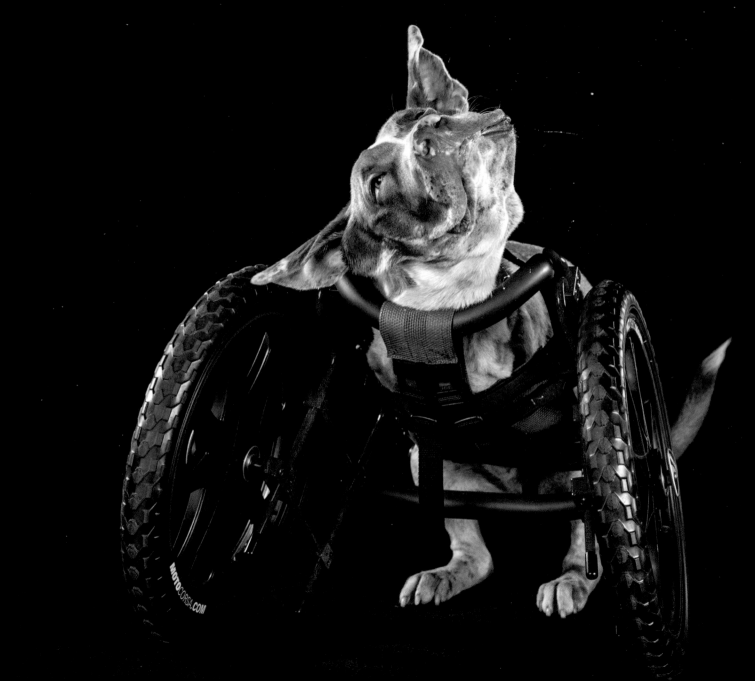

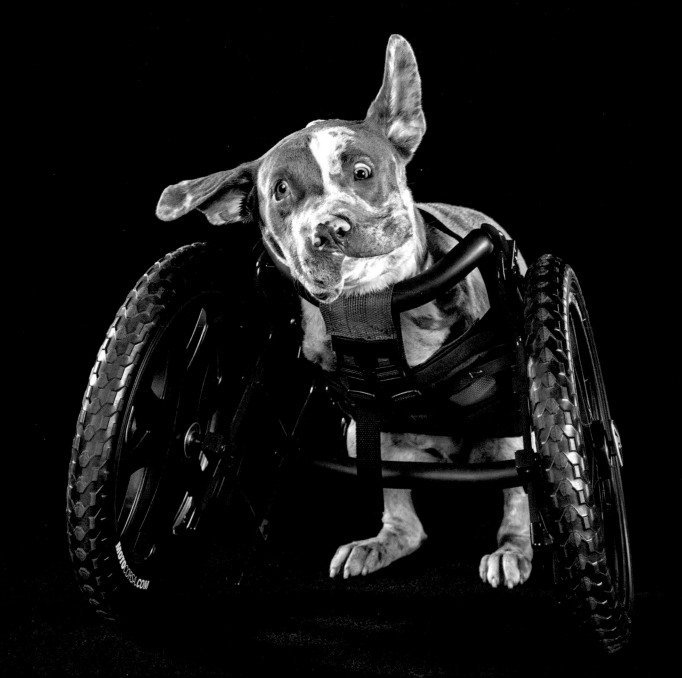

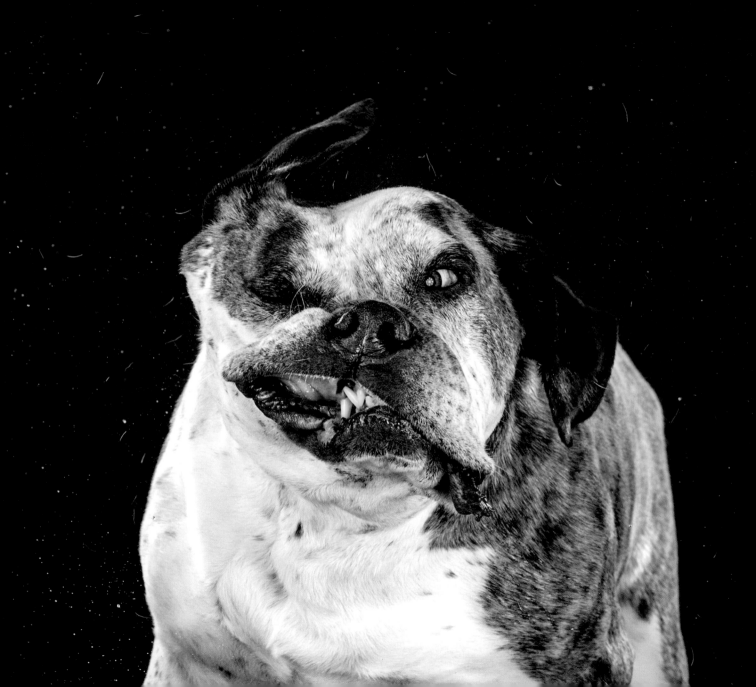

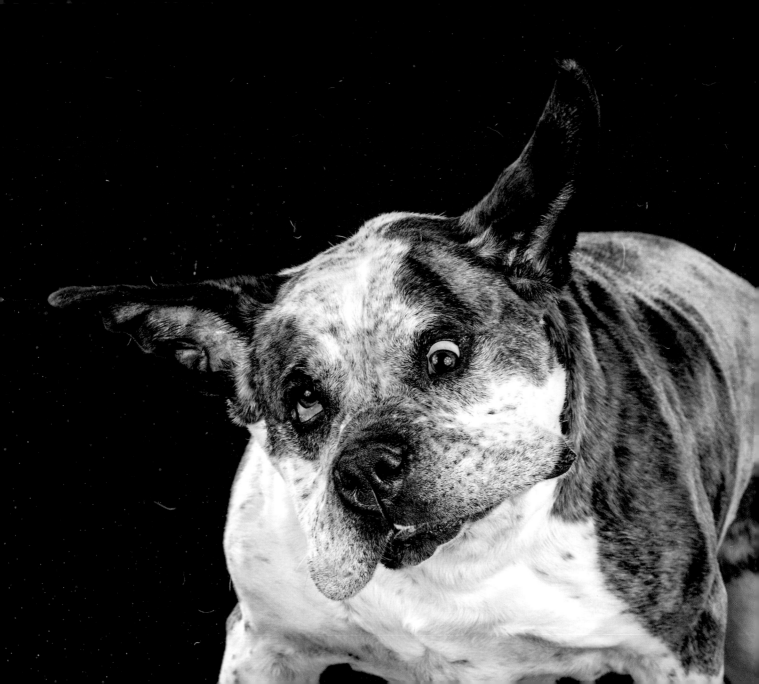

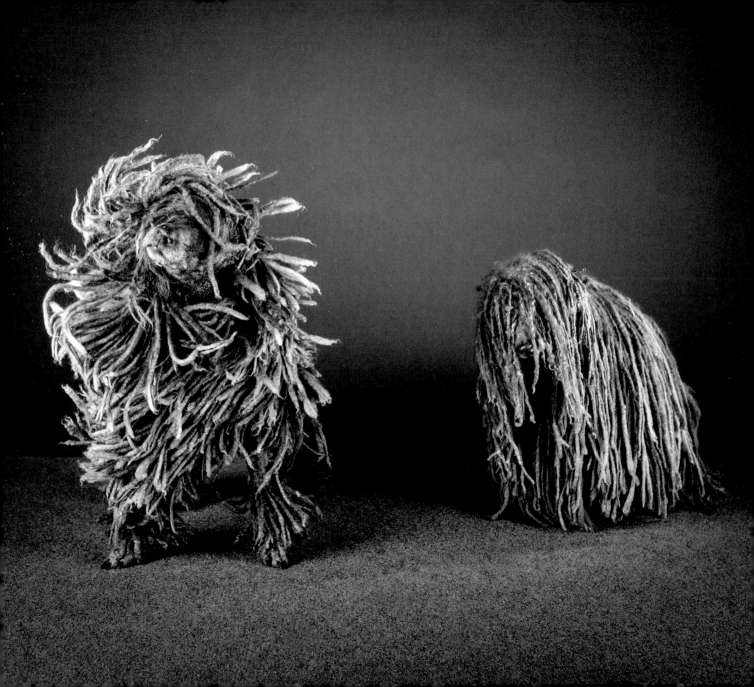

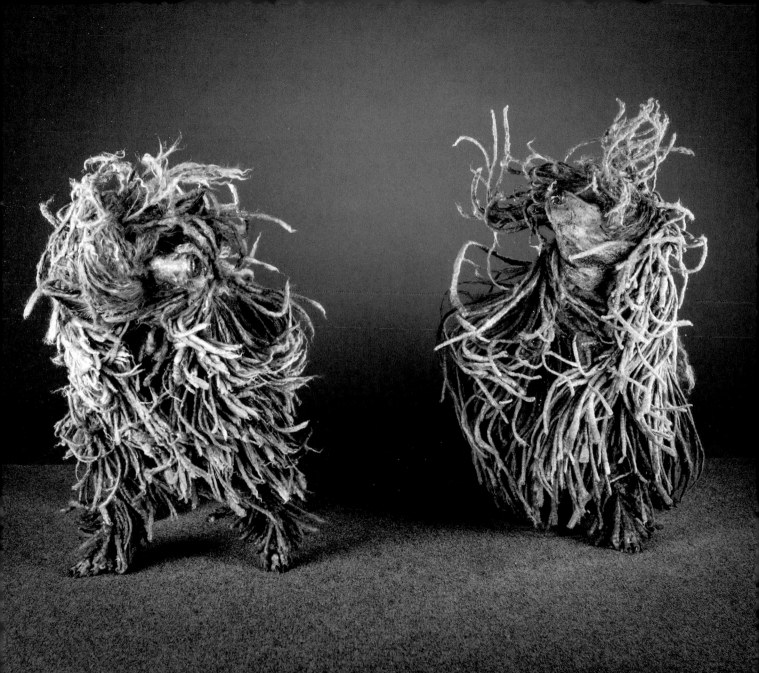

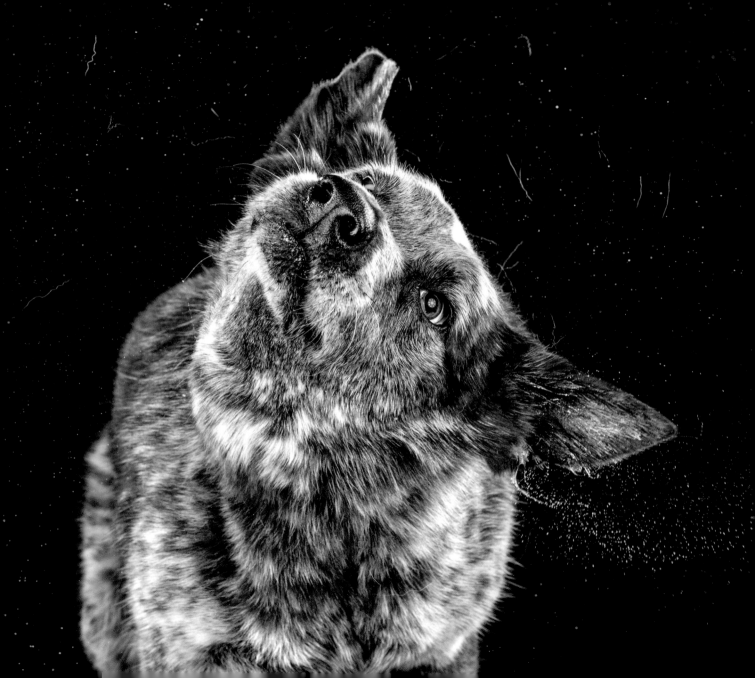

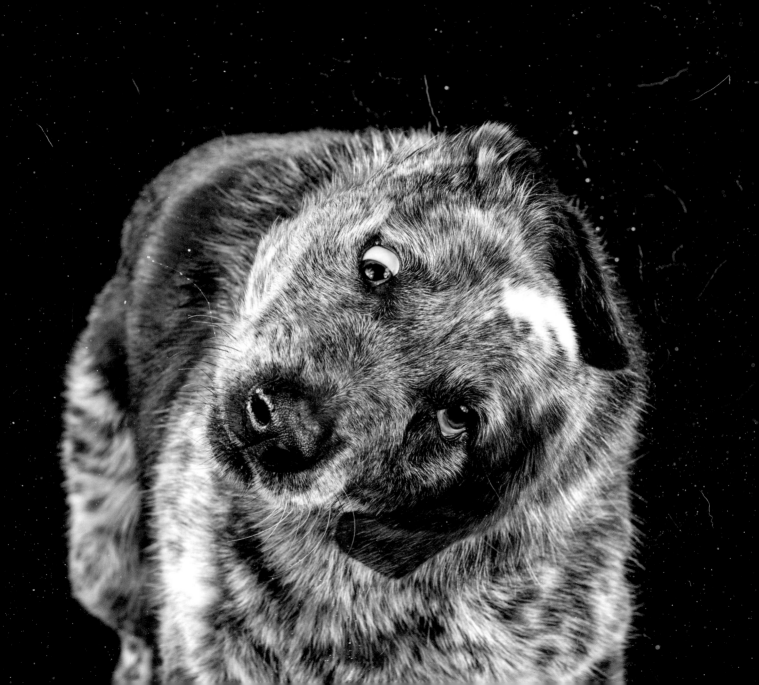

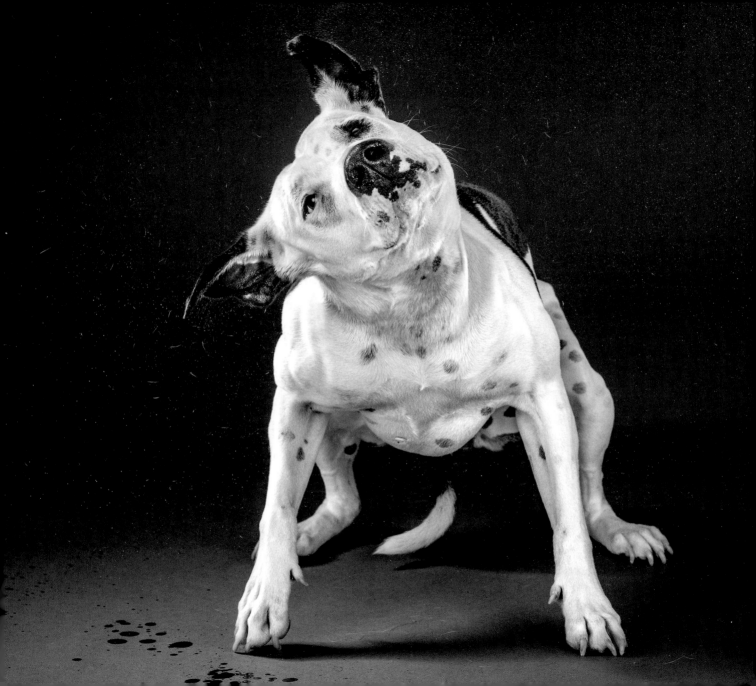

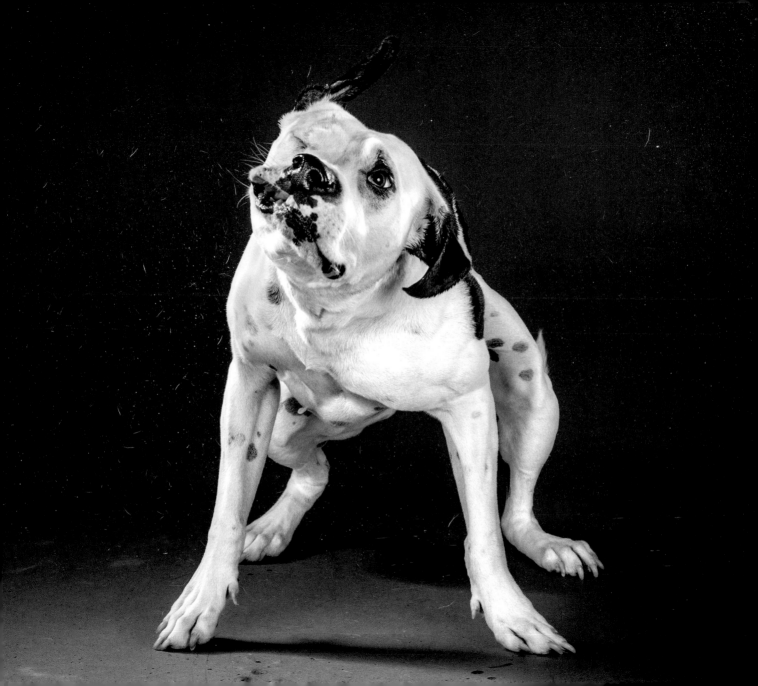

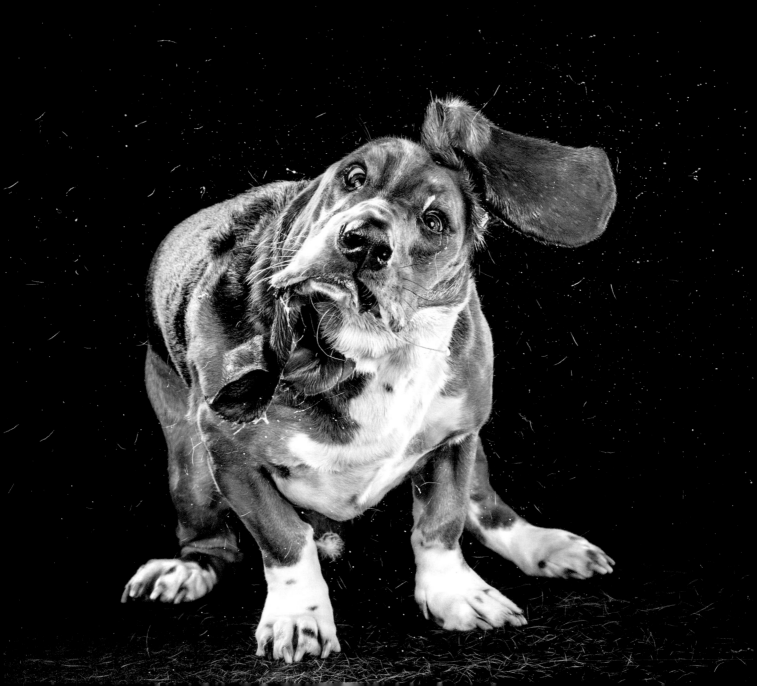

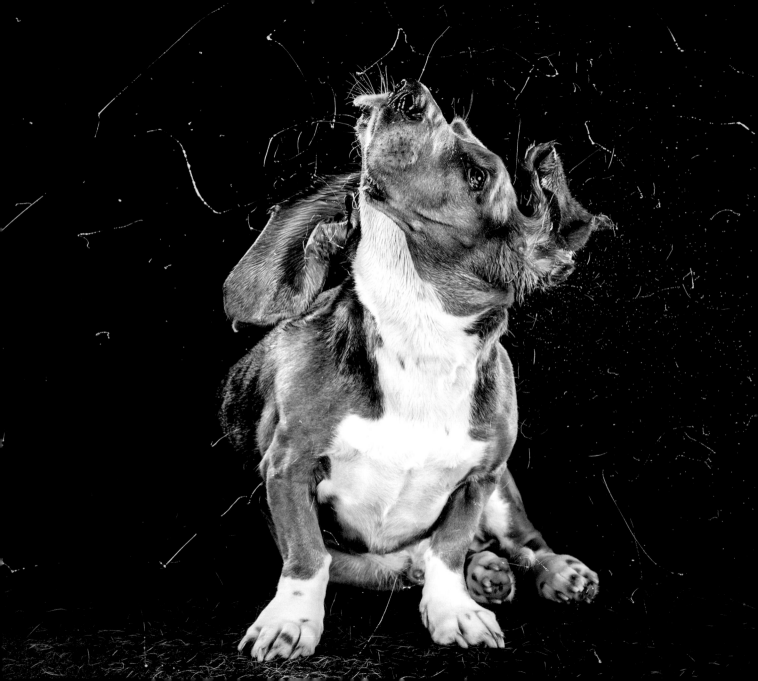

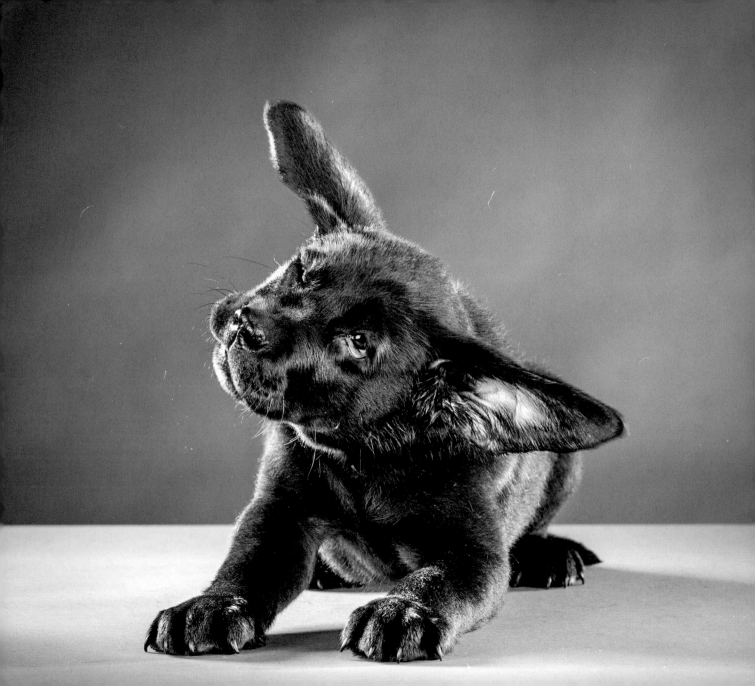

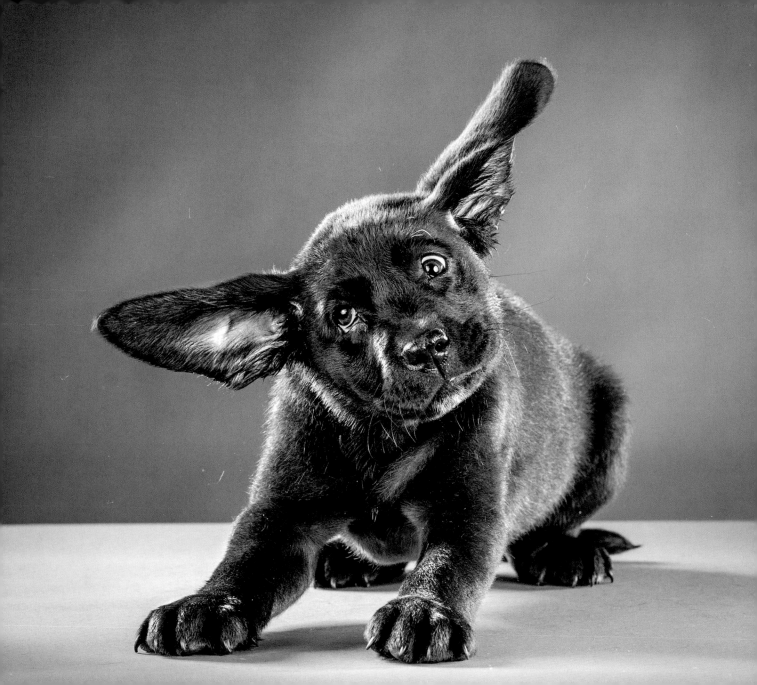

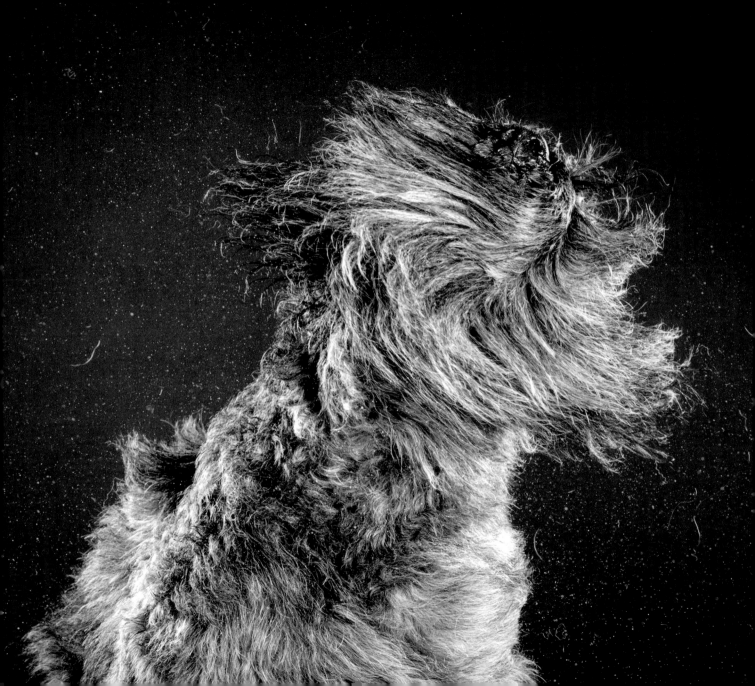

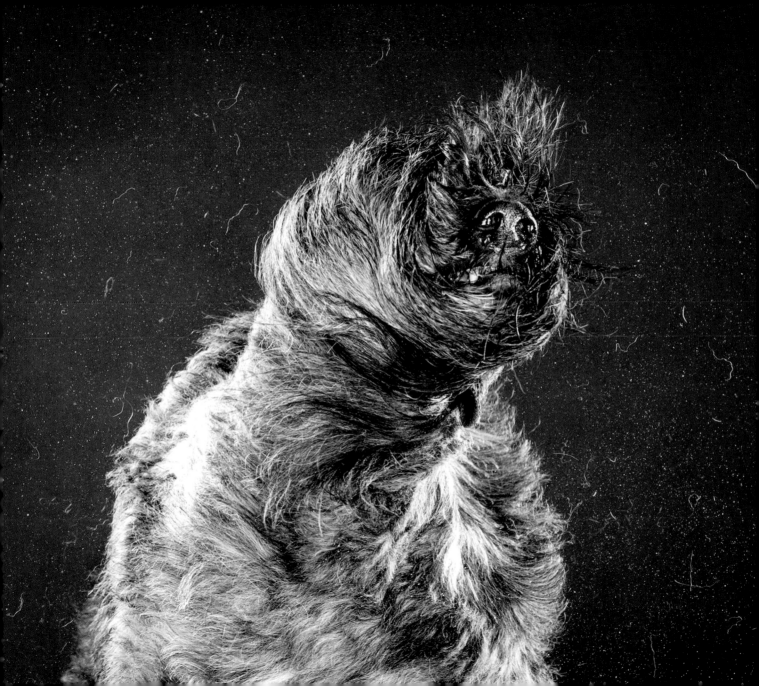

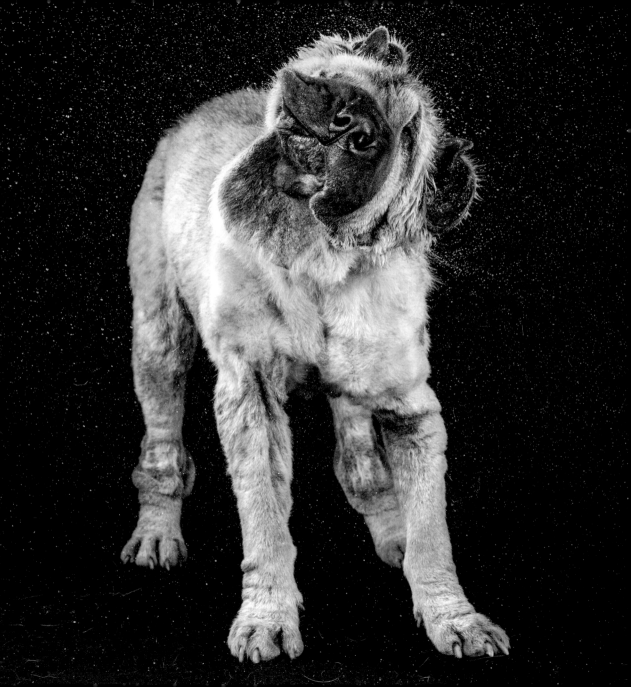

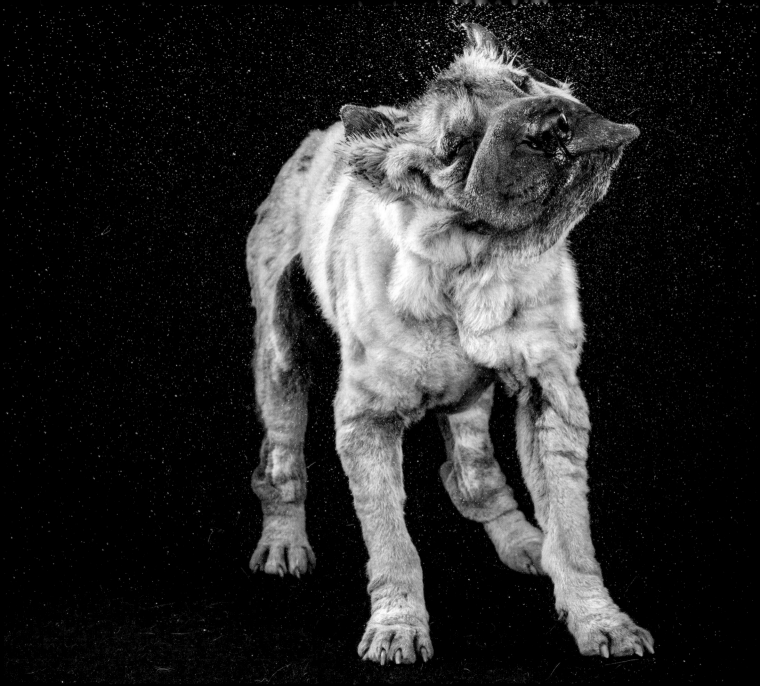

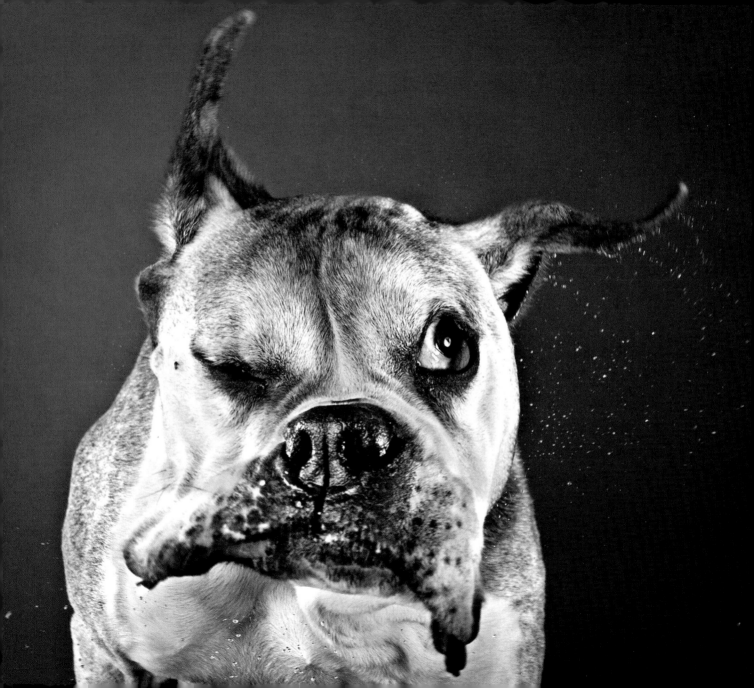

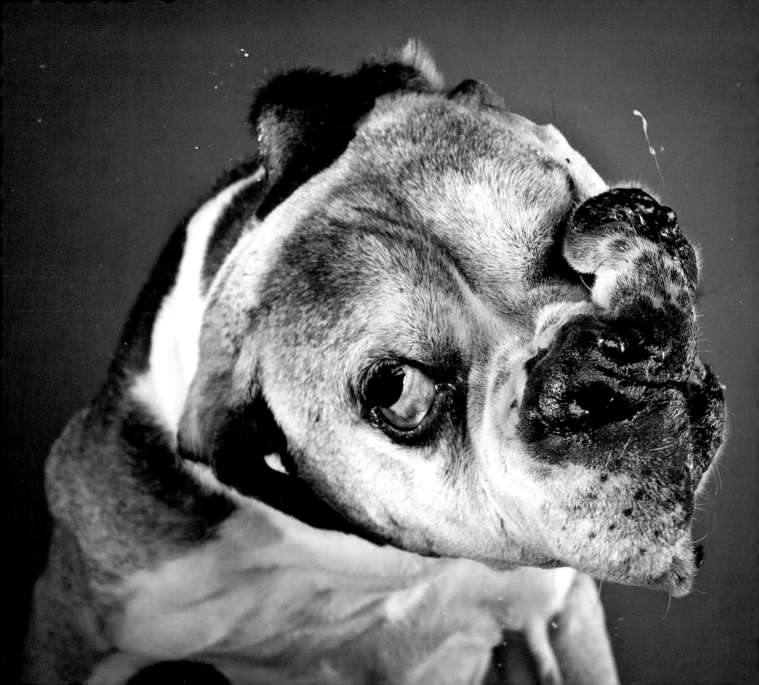

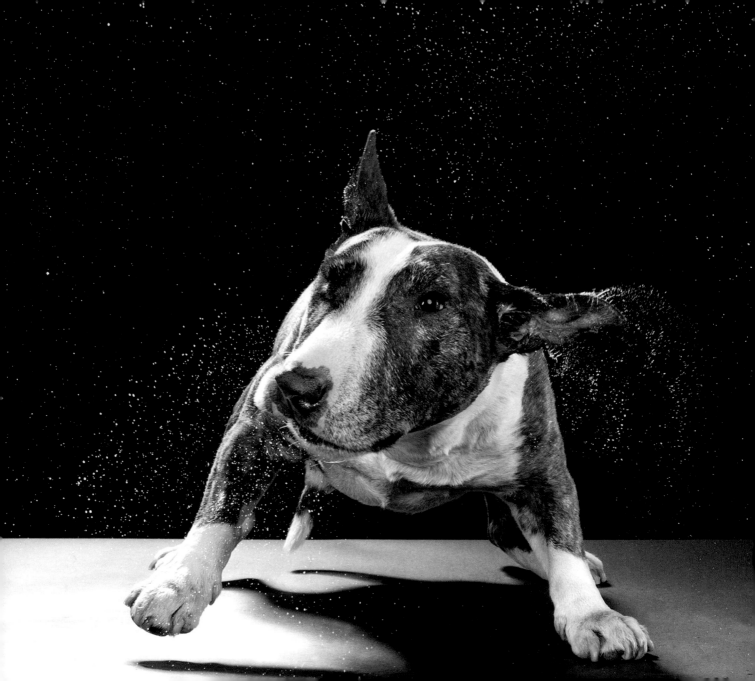

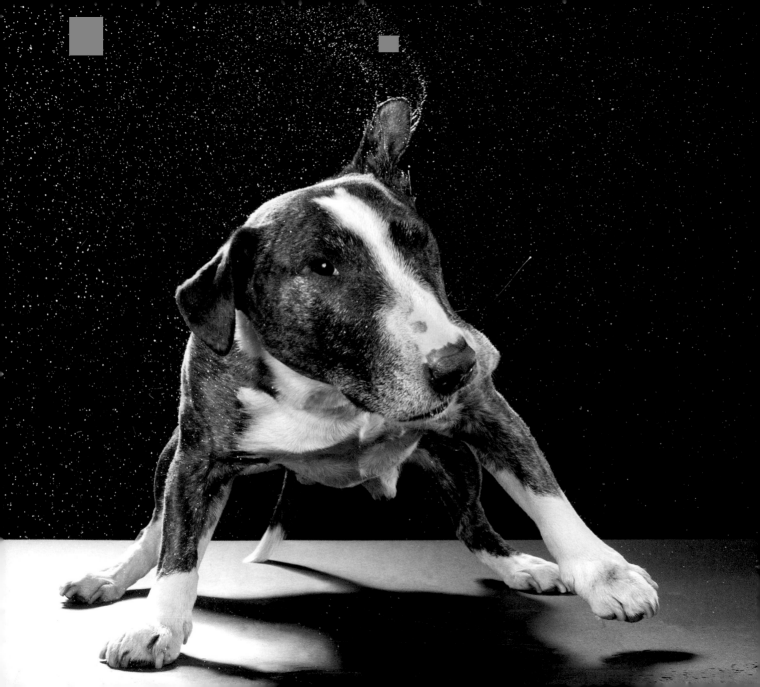

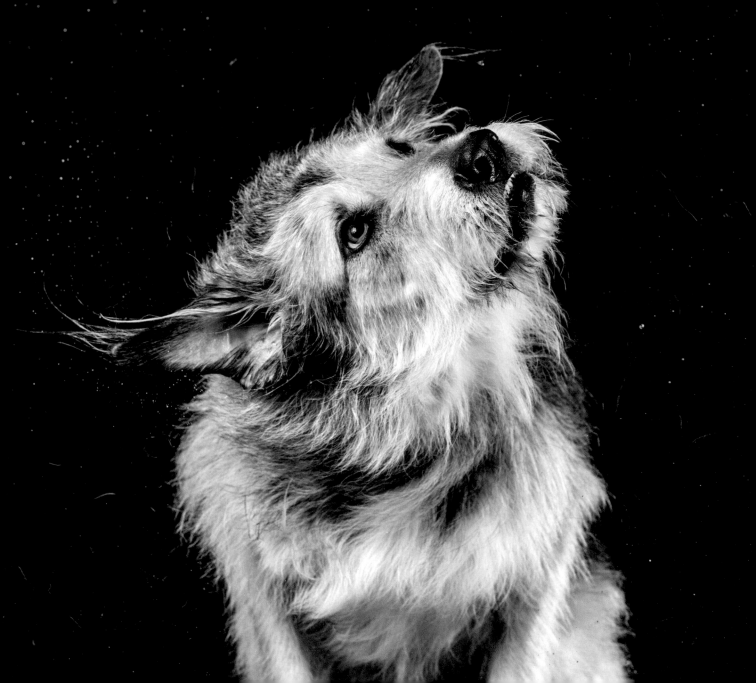

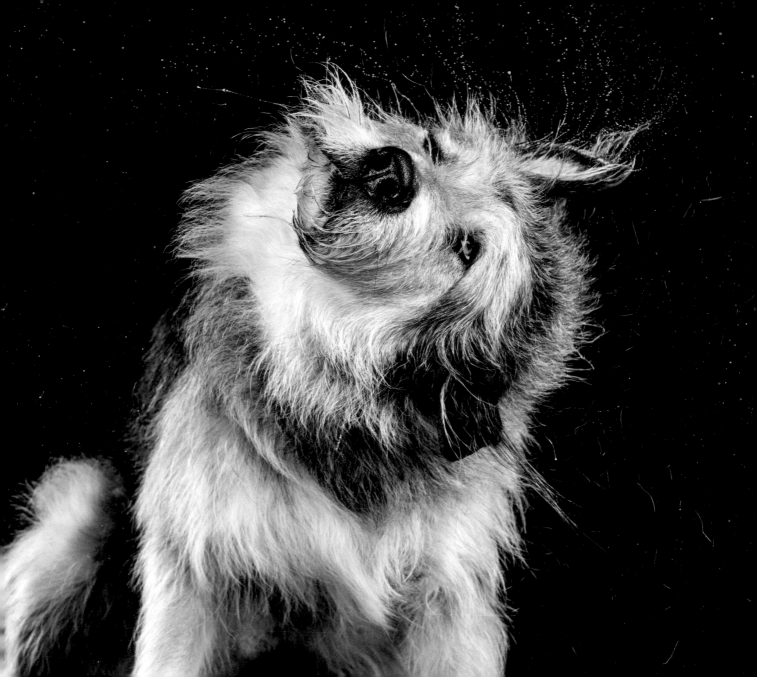

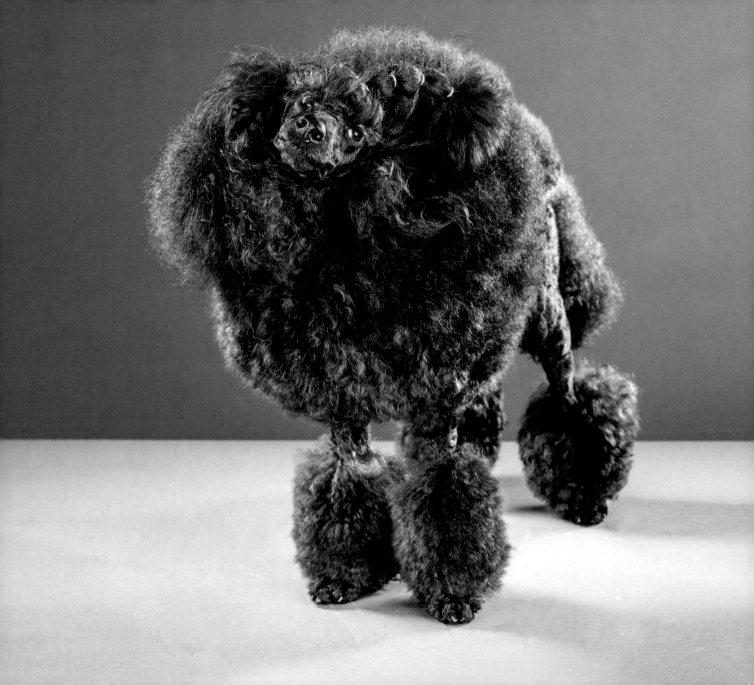

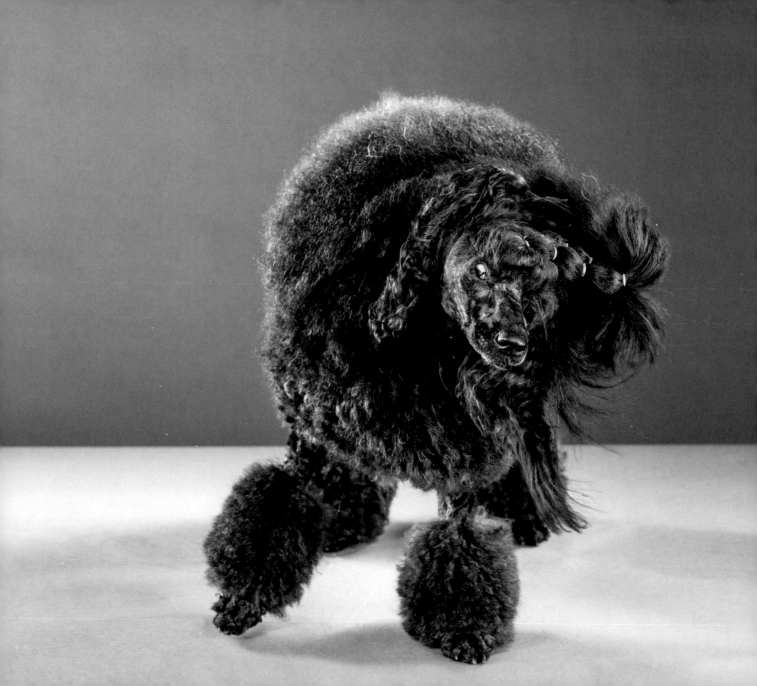

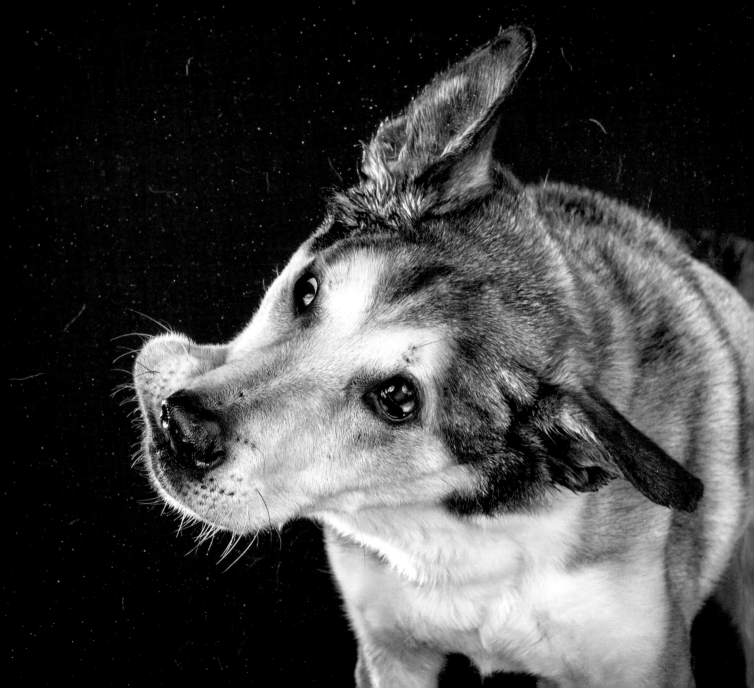

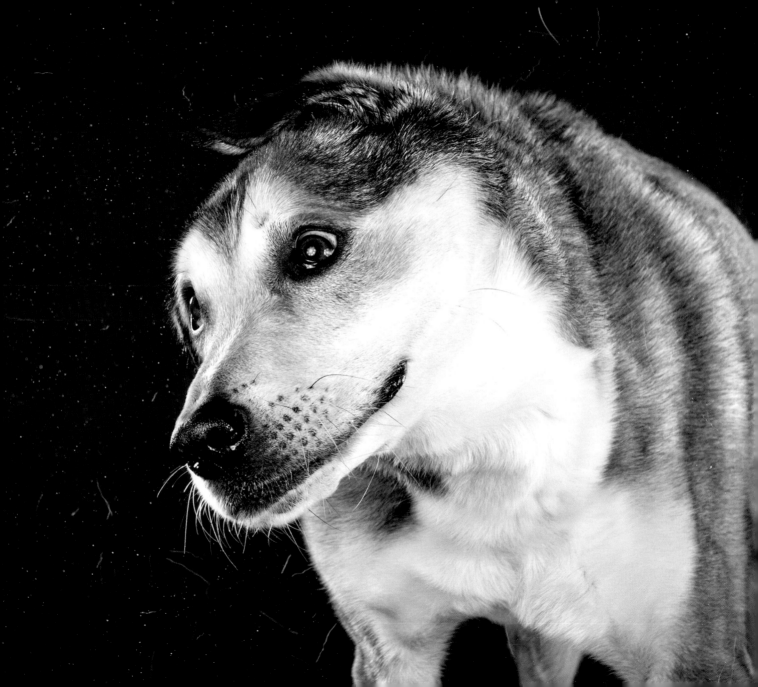

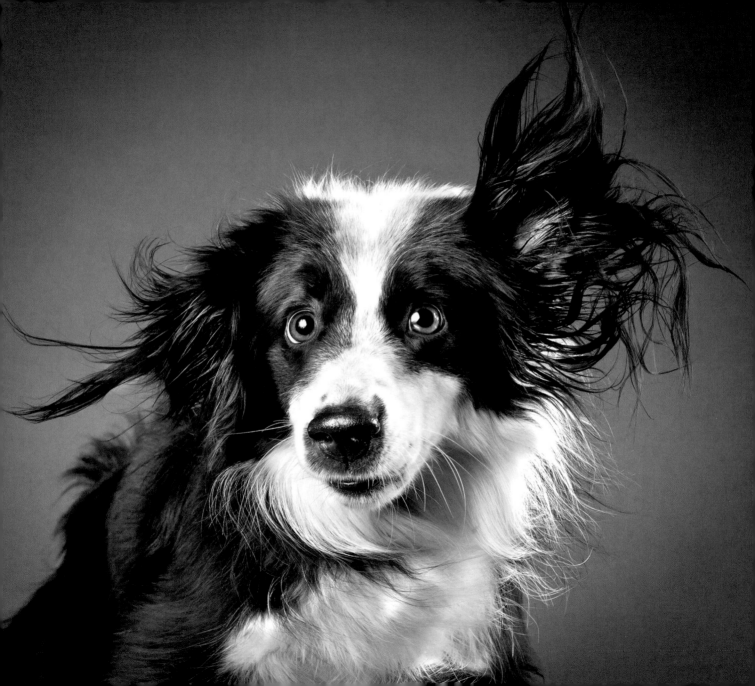

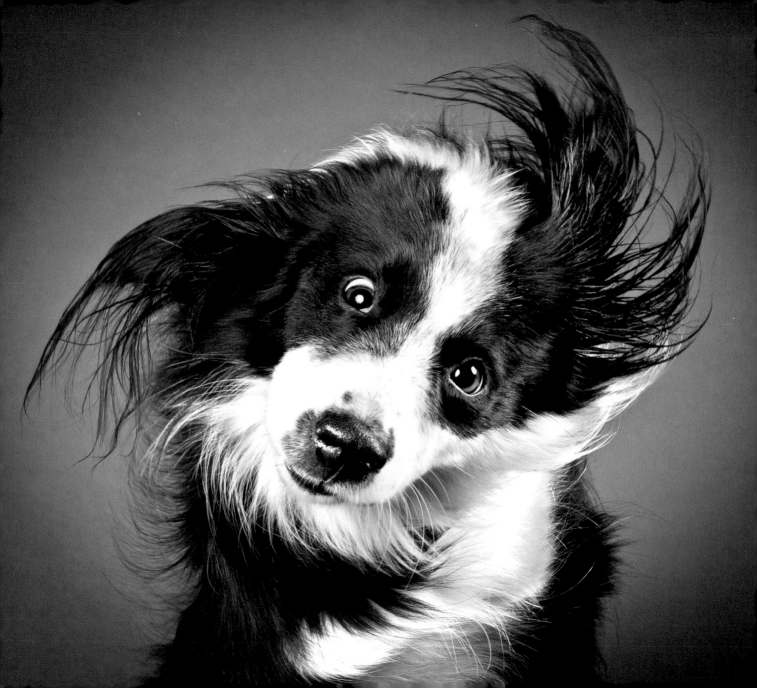

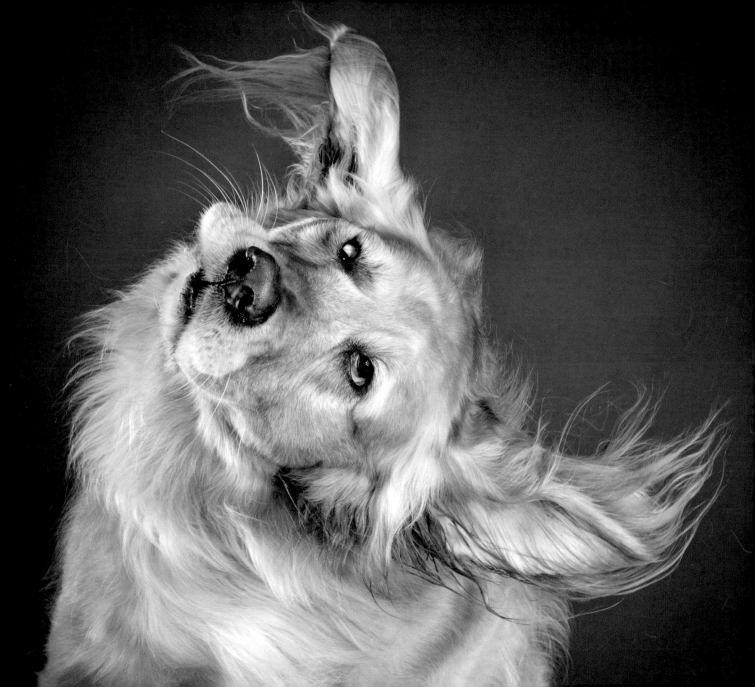

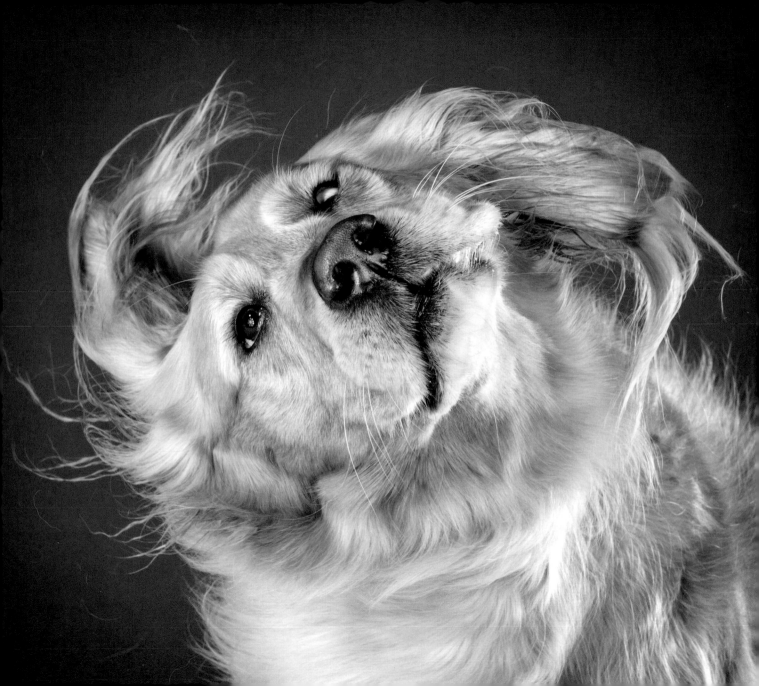

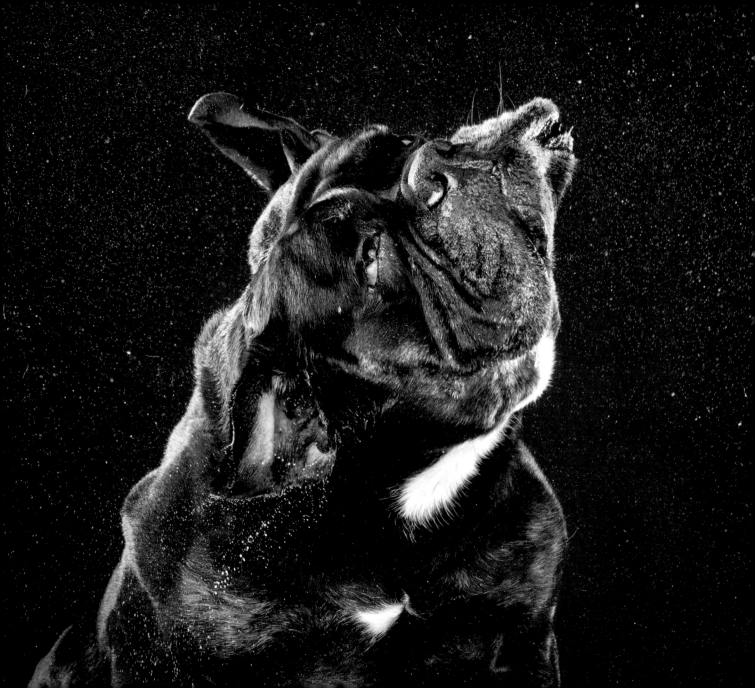

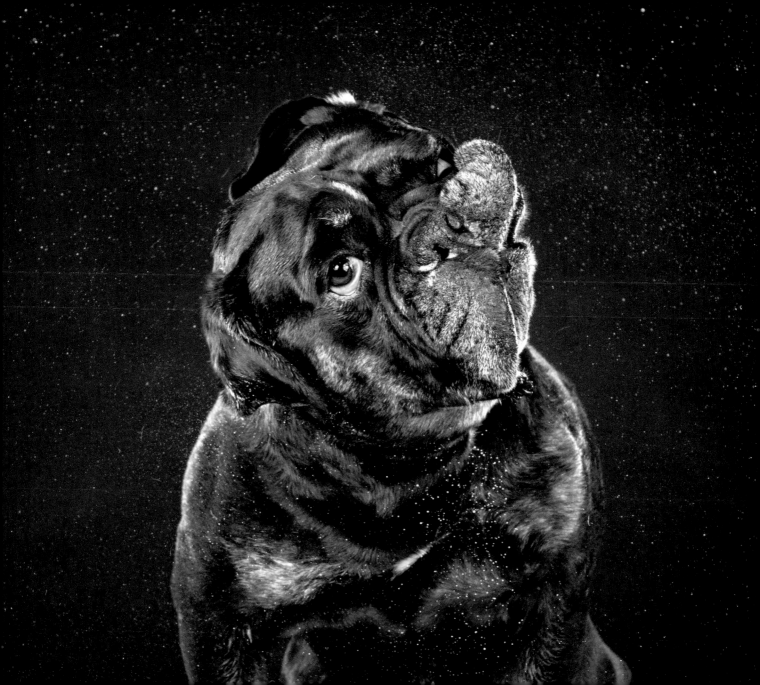

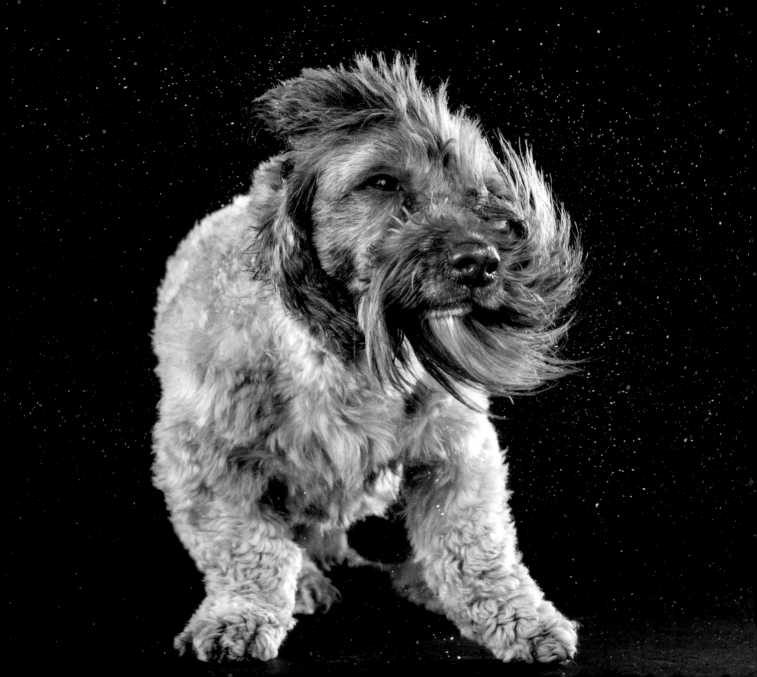

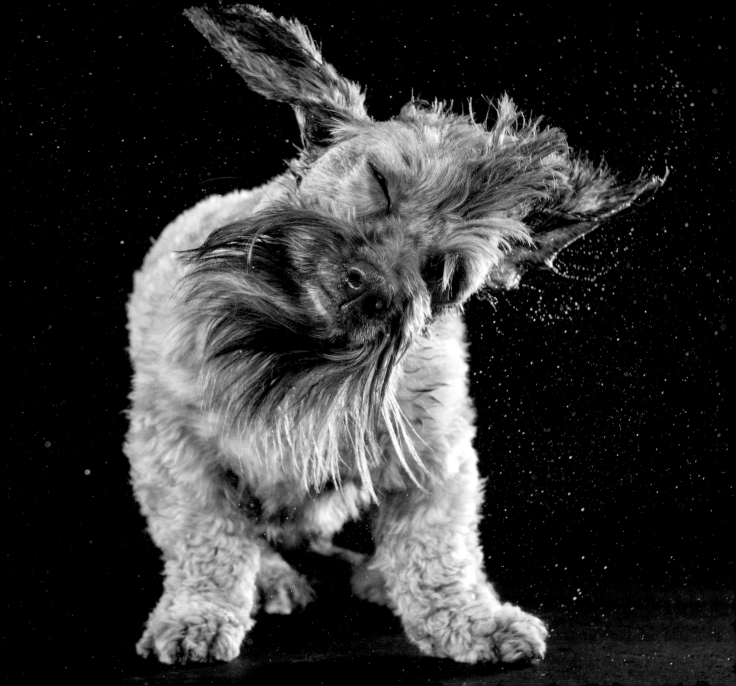

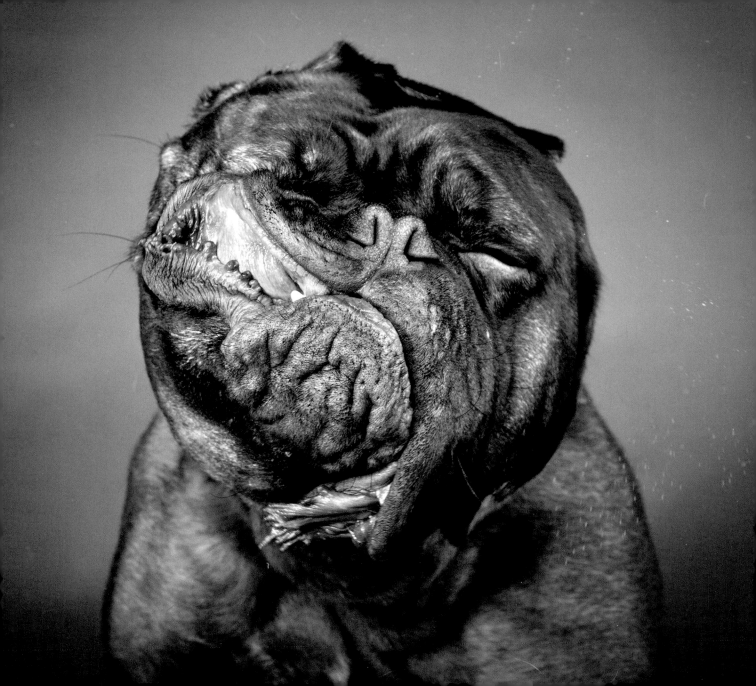

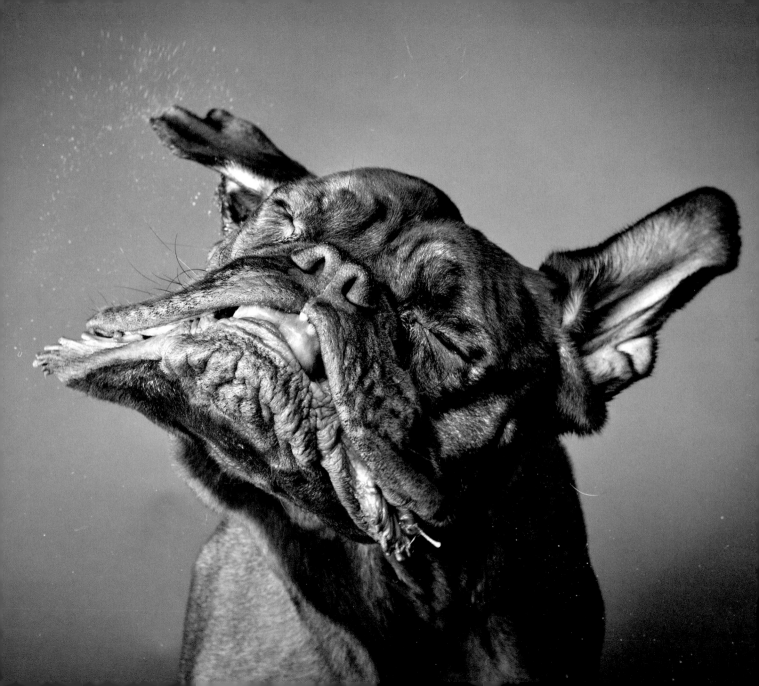

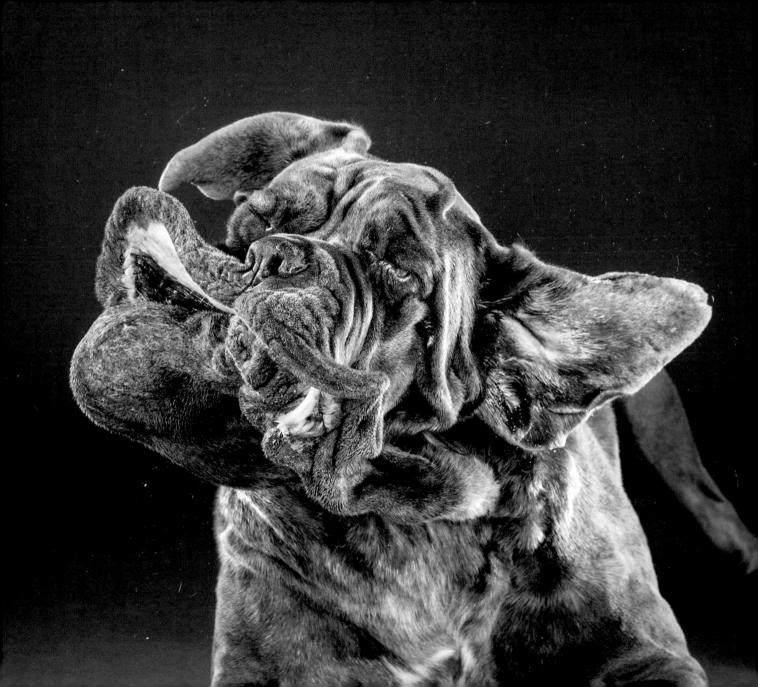

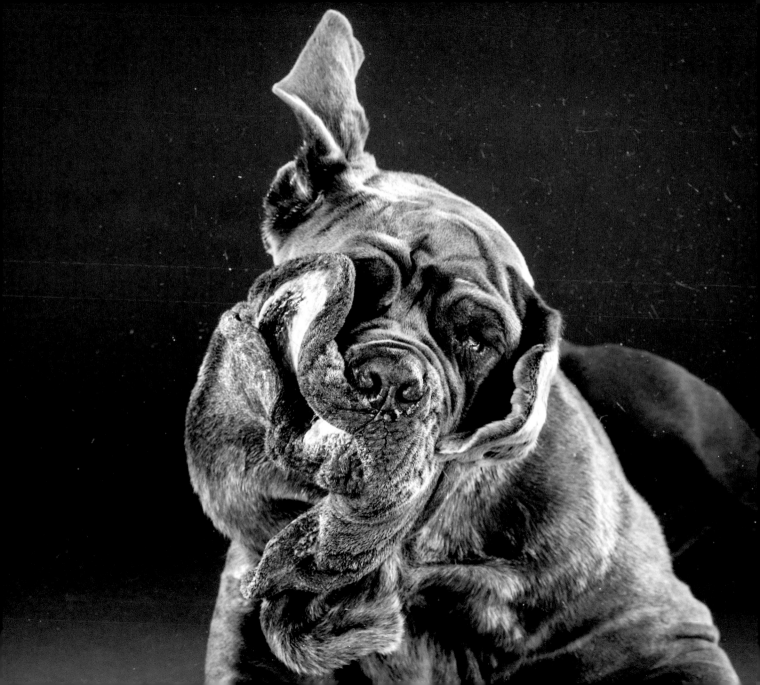

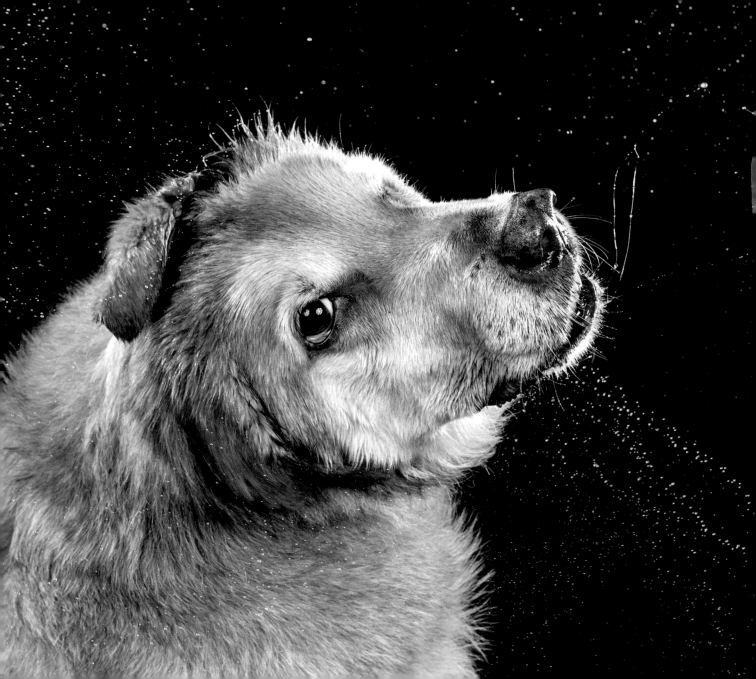

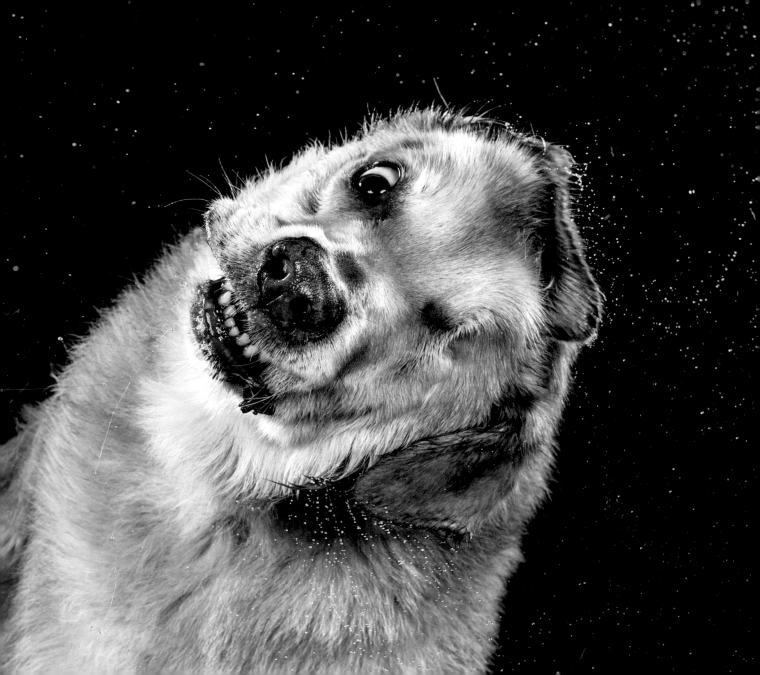

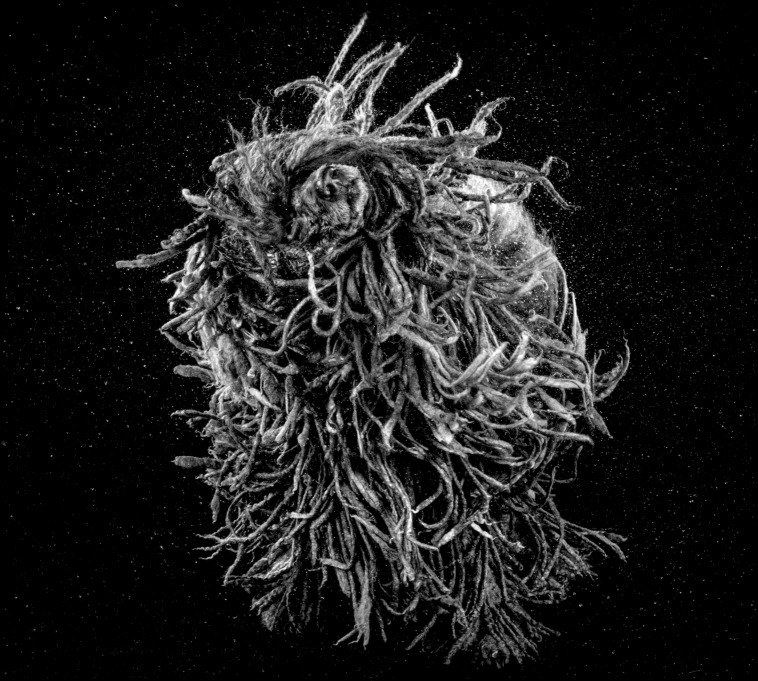

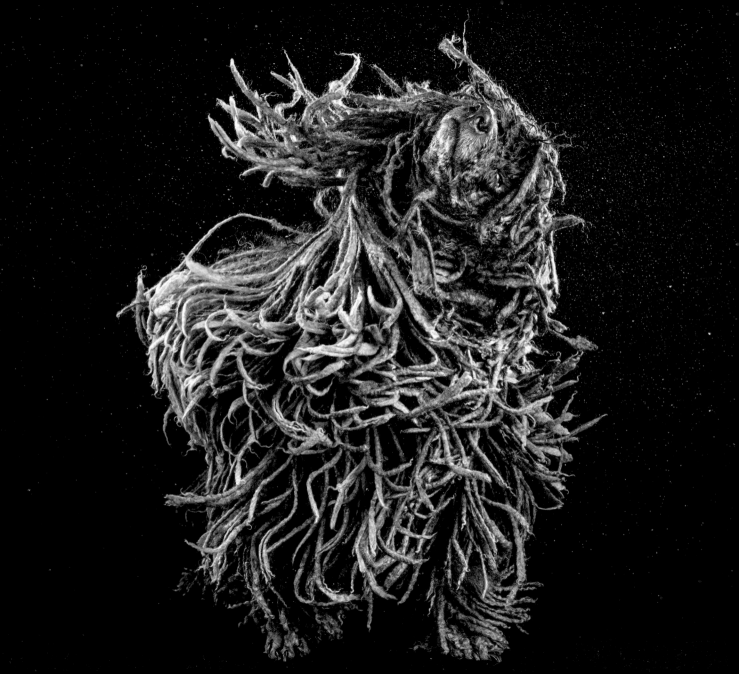

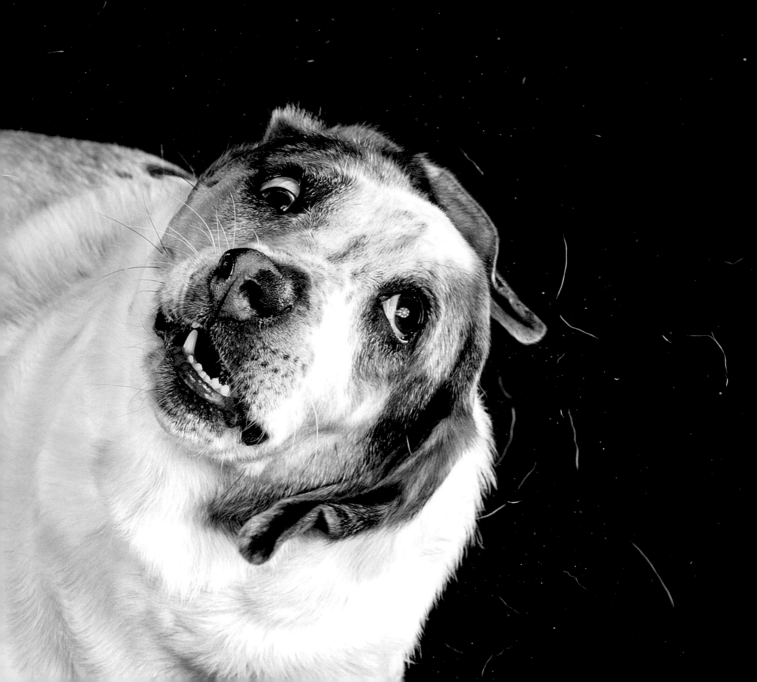

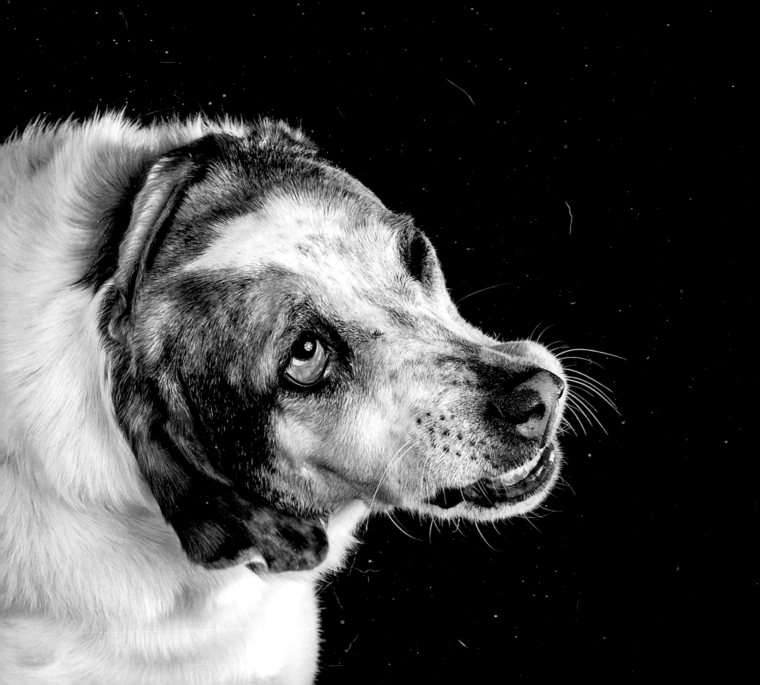

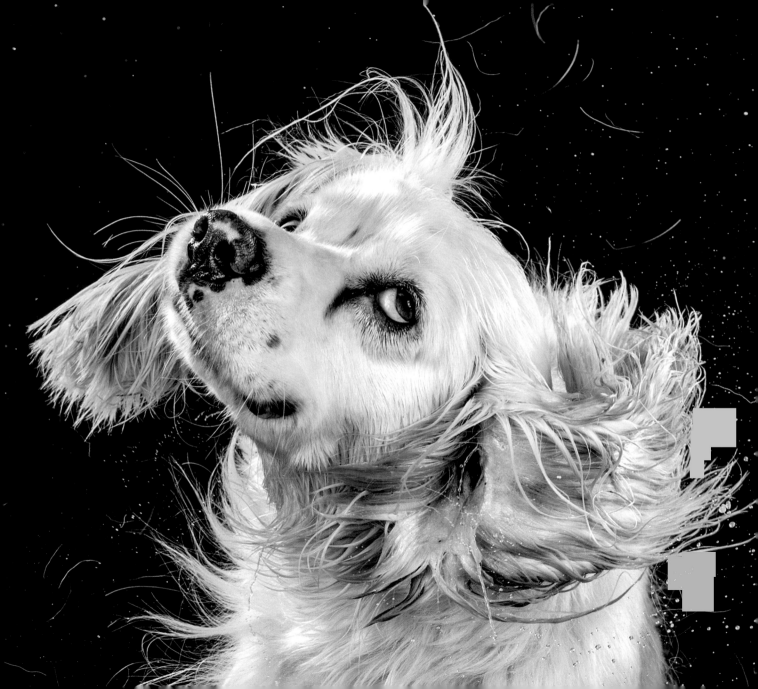

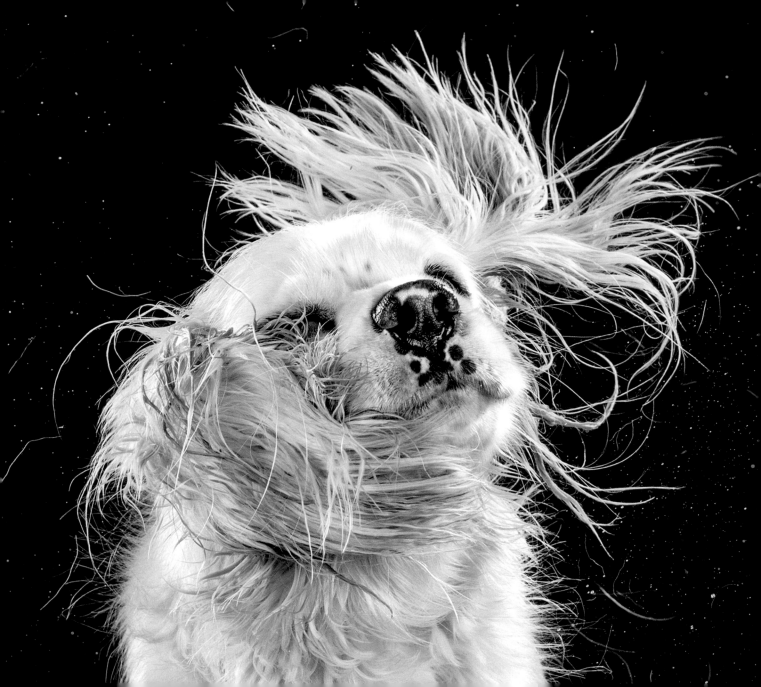

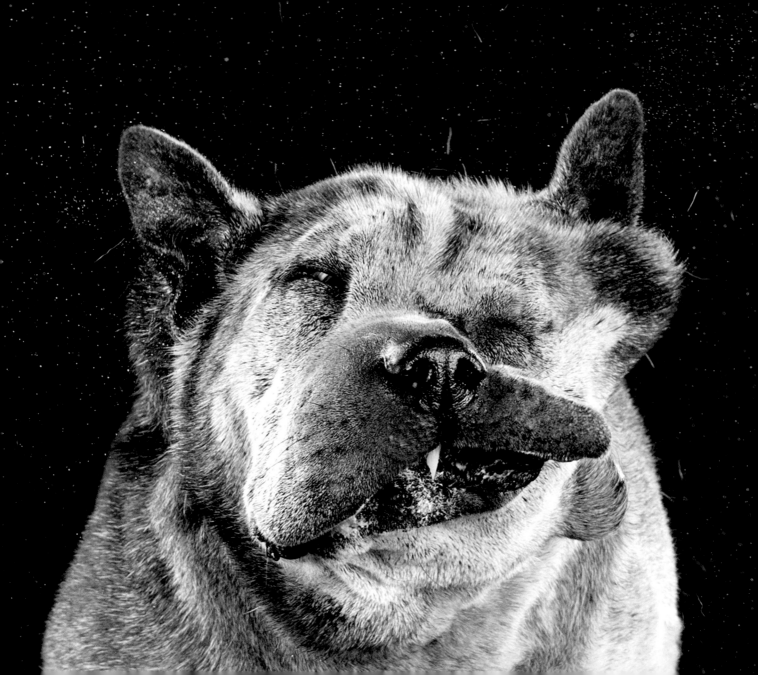

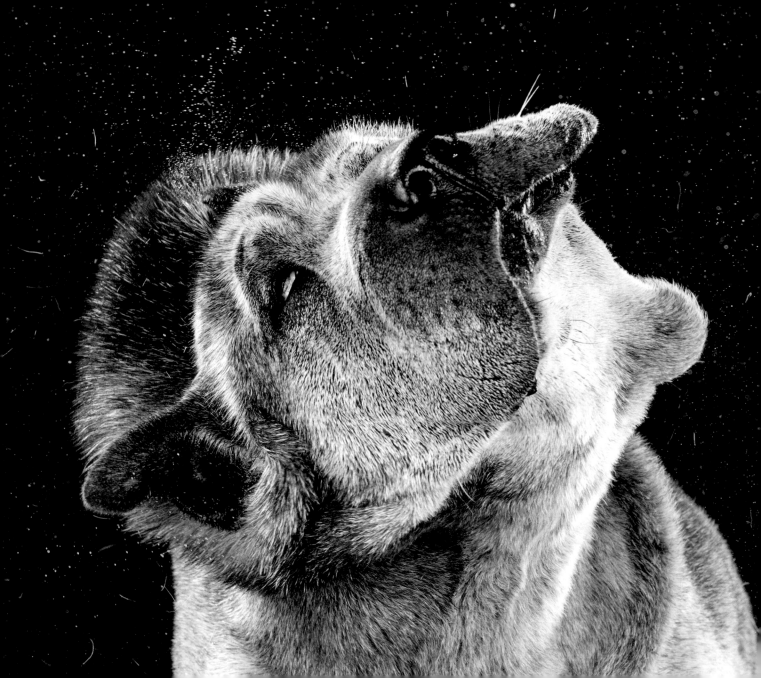

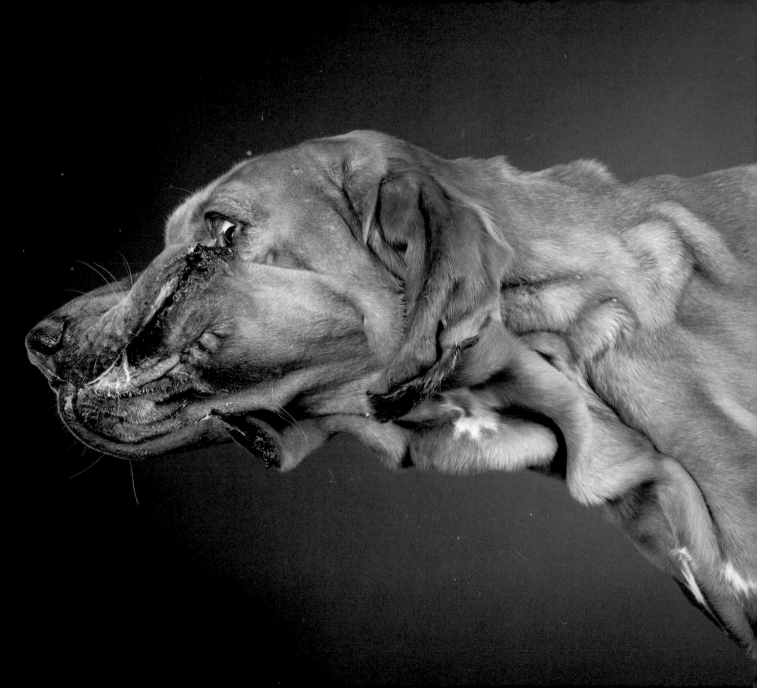

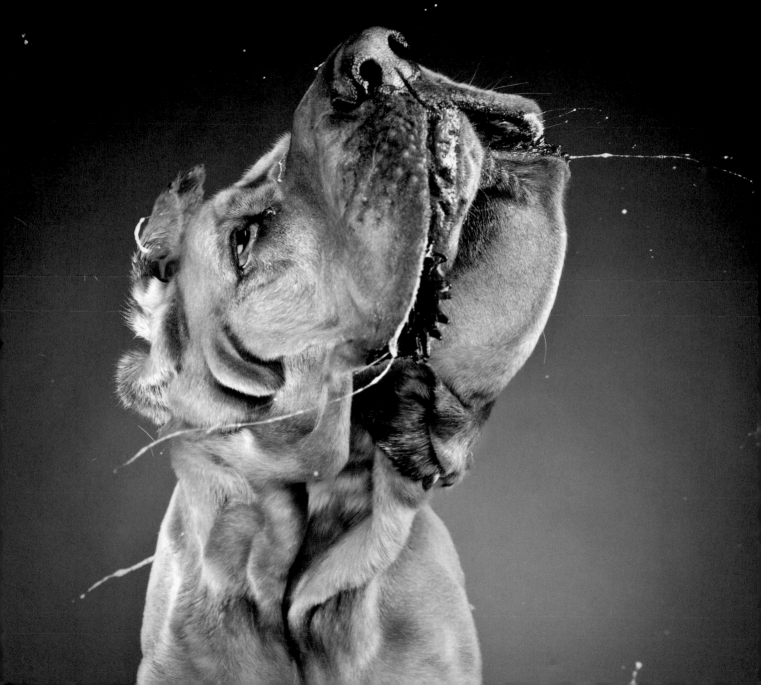

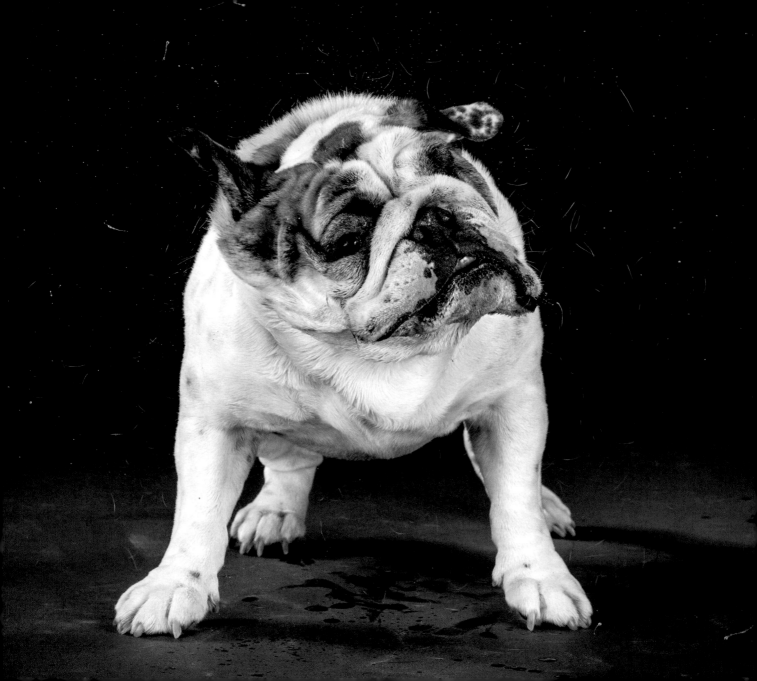

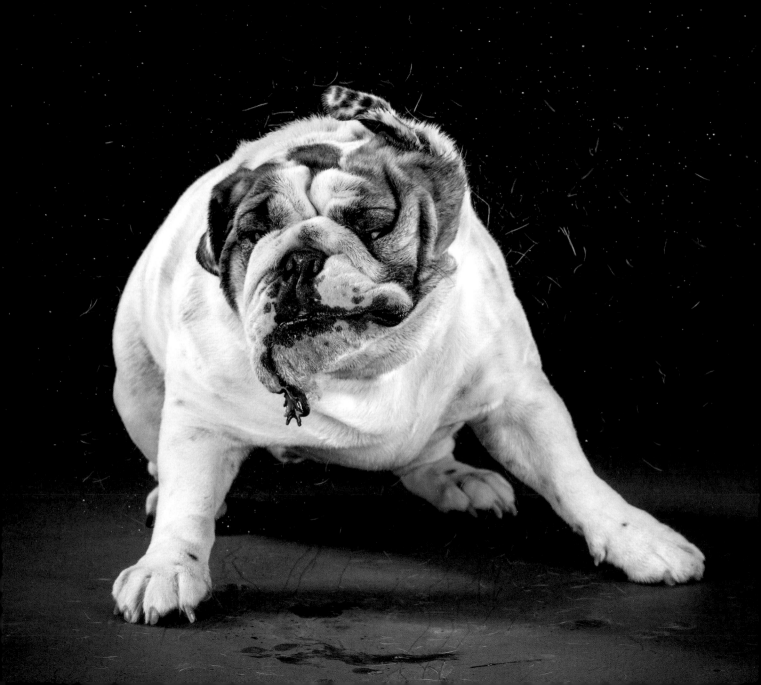

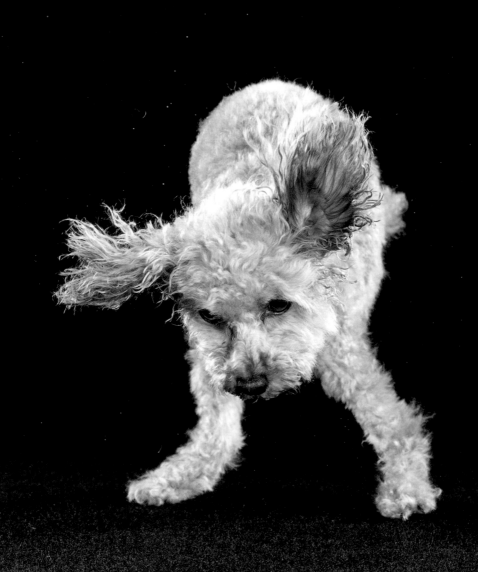

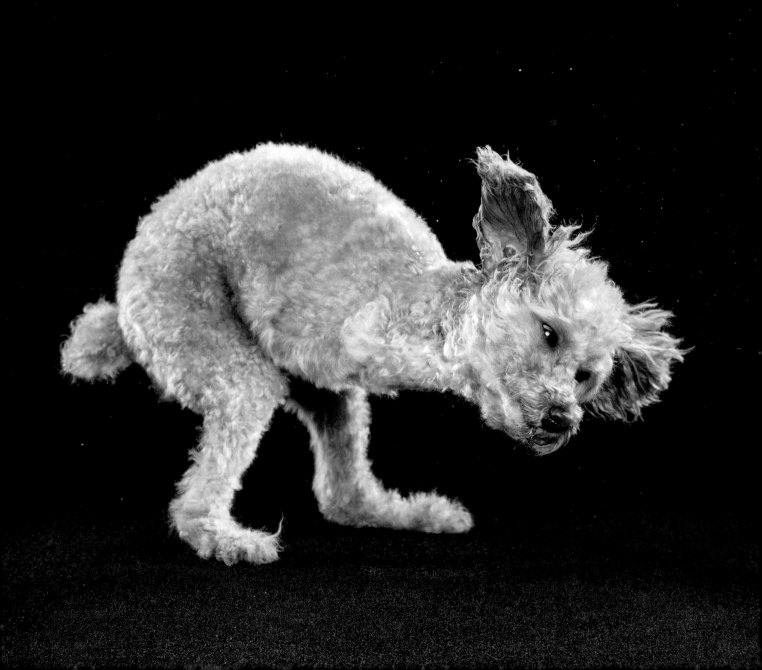

PHOTOGRAPHING THE DOGS

In Temple Grandin's book *Animals in Translation*, she writes about how "animals fear details that people do not notice." In my studio, animals can get distracted and scared by things as simple as a flapping piece of silk, the pop of the camera's flash, and the texture of a paper backdrop. This is why I always strive to normalize the space. I need to take the tension out of a room to set up an animal for success.

With *Shake*, I began each shoot by studying the animal's body language, reading whether it wanted to be ignored and would approach me of its own volition, or if it wanted me to be the first to engage. Those initial moments were critical. I needed to make the animal feel a sense of comfort and control, to build a bridge for communication.

After our initial meet and greet I would encourage the dogs to play with me. My goal was always to create the least stressful situation for the animal. I could then transition from play to the shoot, and I wanted this to be as seamless as possible. It's important that the animal make a positive association with the stage because fear is a shoot killer.

In my work I ask for an extraordinary amount of trust, for the animal to let me put it in front of huge flashing lights and allow me to manipulate its body. I then have to assess what is most likely to get it to shake. Sometimes I sprinkle drops of water on the animal's head. I may scratch its ears, rub it down with a towel, or blow gently on it. Above everything else, my most important tool is patience. Not all the dogs I asked to model for the book chose to shake. Some shook once and let me know they were done. Some shook endlessly and seemed to enjoy the entire process.

Shake took as much technical planning as it did creative. I began by purchasing new strobe lights that pause motion at 1/13,000th of a second. I also needed a camera that could keep up with rapid motion. I shot the majority of the book with the Nikon D4 camera, which is capable of shooting ten frames per second. This was priceless, considering that some dogs would only shake once and it only lasted one or two seconds. Having a variety of shots to work with and choose from was crucial.

Editing these images was a new experience for me. Unlike most of the photography I've done, documenting a moment or staging an idea, I saw the images in *Shake* for the first time only after I shot them. During the shoot the dogs were moving too fast for my eyes to know what their faces looked like. On my camera's viewfinder, I couldn't really get a sense of how distorted they would appear in the photos. This made uploading the most exciting part of the process. The photos came out crisp and clear, and the dogs' expressions were priceless. It was like unwrapping a little gift.

When people ask how to photograph animals, I tell them the first step has nothing to do with photography. Want to know your subject? Volunteer at a shelter, get certified as a dog trainer, or foster dogs for a local rescue. The key is learning how to communicate with animals through experience, time, and patience.

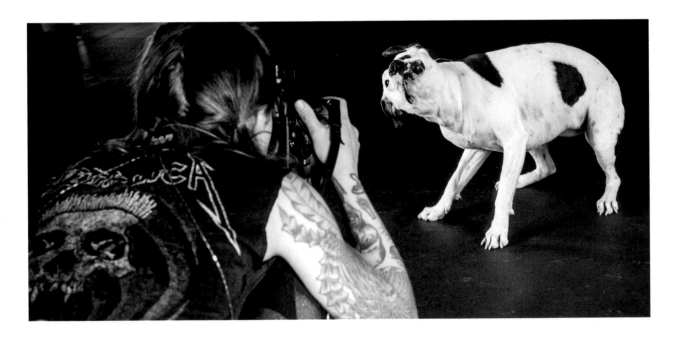

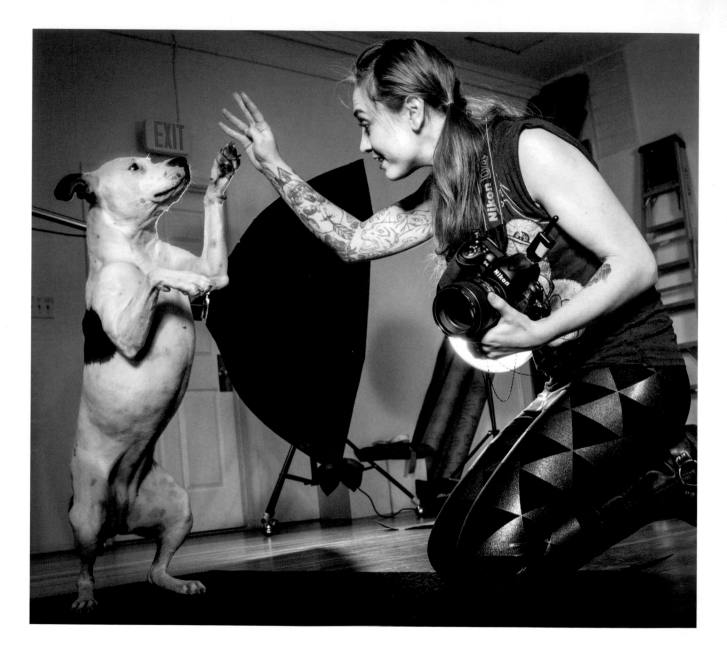

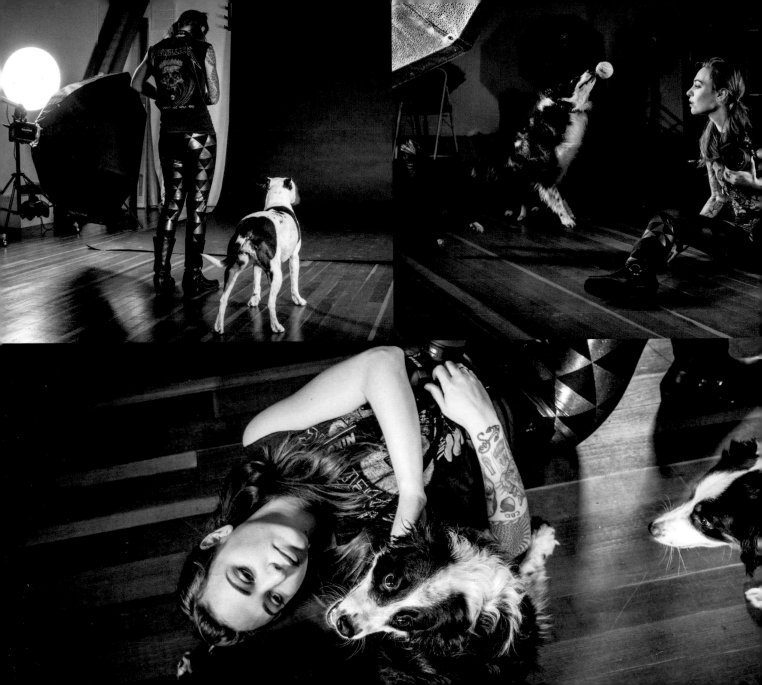

MODELS

Thank you to everyone, near and far, who trusted your dogs to my vision and took the time to come to my studio. I was amazed at how you provided the breeds, looks, and personalities I was asking for. Not all of the dogs I photographed made it into the book, but their willingness to be photographed and the kindness of their owners is still greatly appreciated.

None of the dogs in this book is a professional model. They were sourced through friends, rescue groups, and social media. Because camera equipment is unfamiliar to dogs, the shooting process can be scary for them. But by having their owners there and creating a positive studio environment, almost all of them were playful and upbeat throughout the shoot.

The following are the dog models in order of their first appearance:

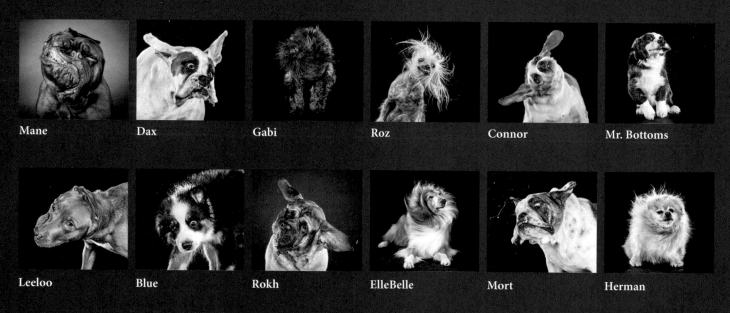

Mane Dax Gabi Roz Connor Mr. Bottoms

Leeloo Blue Rokh ElleBelle Mort Herman

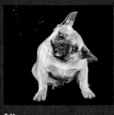

Vito

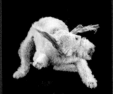

Obiwan

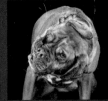

Norbert

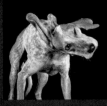

OG

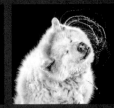

Maddie the
Coonhound

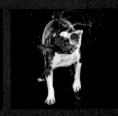

Sunny

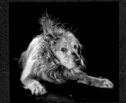

Drew

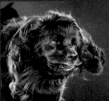

Chewie

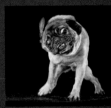

Buddy Nixon

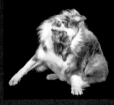

Jake

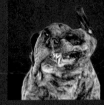

Wyatt

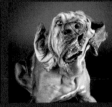

Rocky

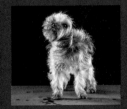

Roscoe

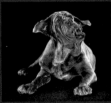

Bella

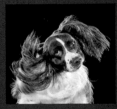

KaDee

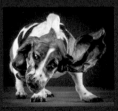

Horus

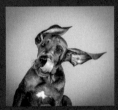

Palmer

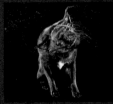

Langston

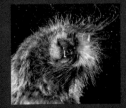

Howard

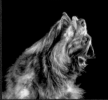

Chloe

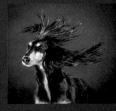

Zorro

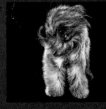

I-Max

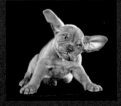

Fonzie

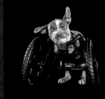

London

141

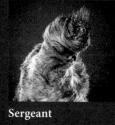
Sergeant

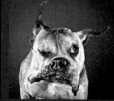
DiDi

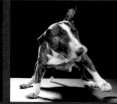
Teuer

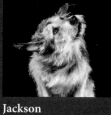
Balboa

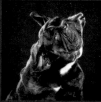
Jackson

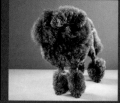
Brio

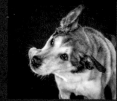
Denali

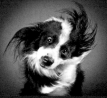
Bailey

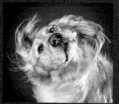
Jewel

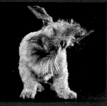
Balrog

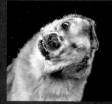
Darius

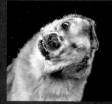
Bandit

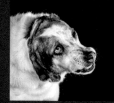
Nancy Drew

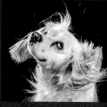
Bumble

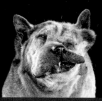
Grandpa

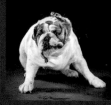
Huey

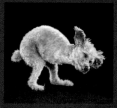
Ramen Noodle

A NOTE ON ANIMAL ADOPTION

Animal lovers of the world, I want to ask you to please consider adopting your next pet. Mutts are all the rage right now. They're unique, and they are less prone to genetic disorders than are their purebred counterparts. If a specific breed is what you're after, don't worry; 25 percent of dogs that end up at rescues are purebreds (that's more than a million per year). Shelter animals know you saved them and show their appreciation in their sensitivity and affection. In adopting a rescue, you are literally saving a life.

Also consider an older dog or special-needs one. Be honest—are you super busy with work, or a couch potato? Get a dog that can groove with your lifestyle. A puppy is a crazy play-machine that needs constant training and attention for at least two years. A seven-year-old pit bull mix will want to drool on your lap while you eat Cheetos and watch *Ellen*, and it will already know not to poop on your antique Persian rug.

Spaying or neutering your pet is necessary if we are ever going to end shelter overpopulation. Without this, your dog's unexpected offspring could end up being one of the three to four million pets euthanized every year. Unaltered females live shorter lives than spayed females. Unaltered males are a recipe for aggressive behavior, and are responsible for more than 90 percent of fatal dog attacks. If you feel the need, you can buy your dog some fancy neuticles (testicular implants). I will still judge you, but way less so than if you don't neuter your dog.

Seventy percent of the dogs in this book are rescues. Most were saved by Panda Paws Rescue, a Portland-based nonprofit whose mission of rescuing, rehabbing, and finding homes for elderly, injured, and special-needs animals I truly believe in. Support your local rescues. If you are a photographer, please consider donating your photo services to a rescue in need.

ACKNOWLEDGMENTS

The first person I must acknowledge is Amanda Giese, founder of Panda Paws Rescue. Her dog Mane, my first *Shake* model, was very patient in letting me hone my techniques to get the desired effects. Amanda also helped with production and assisted me during a majority of the *Shake* shoots.

I am beyond grateful to my wonderful agent, Jean Sagendorph, for seeing the potential in my work and finding a home for this book. I am also thankful to my editor, Julia Abramoff, for directing me through my first book. It's been an amazing experience.

Thanks to those who taught me about animal care and training, starting with the staff at Teatown Lake Reservation when I was a kid and, later, the Oregon Zoo staff, including Tanya Paul, Nicole Nicassio, Julie Christy, Shannon LaMonica, Bree Booth, and lastly Virginia Grimly, who taught me nothing but will throw a fit if her name is not on this list.

Thanks to the many people who are my photography mentors, including Andi Davidson, Michael Rudin, Joanne Kim, Gio Marcus, Holly Andres, Michael Durham, Brad Guice, and Frank Ockenfels.

For their overall support, thanks to Sierra Hahn, Joseph Russo, Steven Michael Reichert, Scott Cook, Salisha Fingerhut, Jennifer Harris, Dori Johnson, Deena Davidson, Leslie Davidson, Barbara Davidson, all the Wieschs and kin, Kuo-Yu Liang, Joe Preston, Eric Powell, Alana DeFonseca, Danica Anderson, Hukee, Carlos Donahue, Janice Moses, Cheyanne Alott, Pasha, Sarah Grace McCandless, Lance Kreiter, Krisi Rose, Randy Stradley, Matt Parkenson, Jeremy Atkins, John Schork, Seth Casteel, Mike and Bub, Greg Morrison, Jonny Lockwood, Erica Dehil, Hannah Ingram, Scott Harrison, Jen Lin, Ali Skiba, Moira Morel, Gary Walters, Beast and Jade, Jen Agosta, Bridget Irish, Kevin Habberstad, Travis and Jeff Becker, Nikon, the crew at Variable, my team at HarperCollins, including Lynne Yeamans, Joel Cáceres, and Michael Barrs, all of my friends who inspire me every single day, and my husband, Tim Wiesch, who is always ready to greet me after a long shoot with a homemade meal and a killer bear hug.